Anne Savage

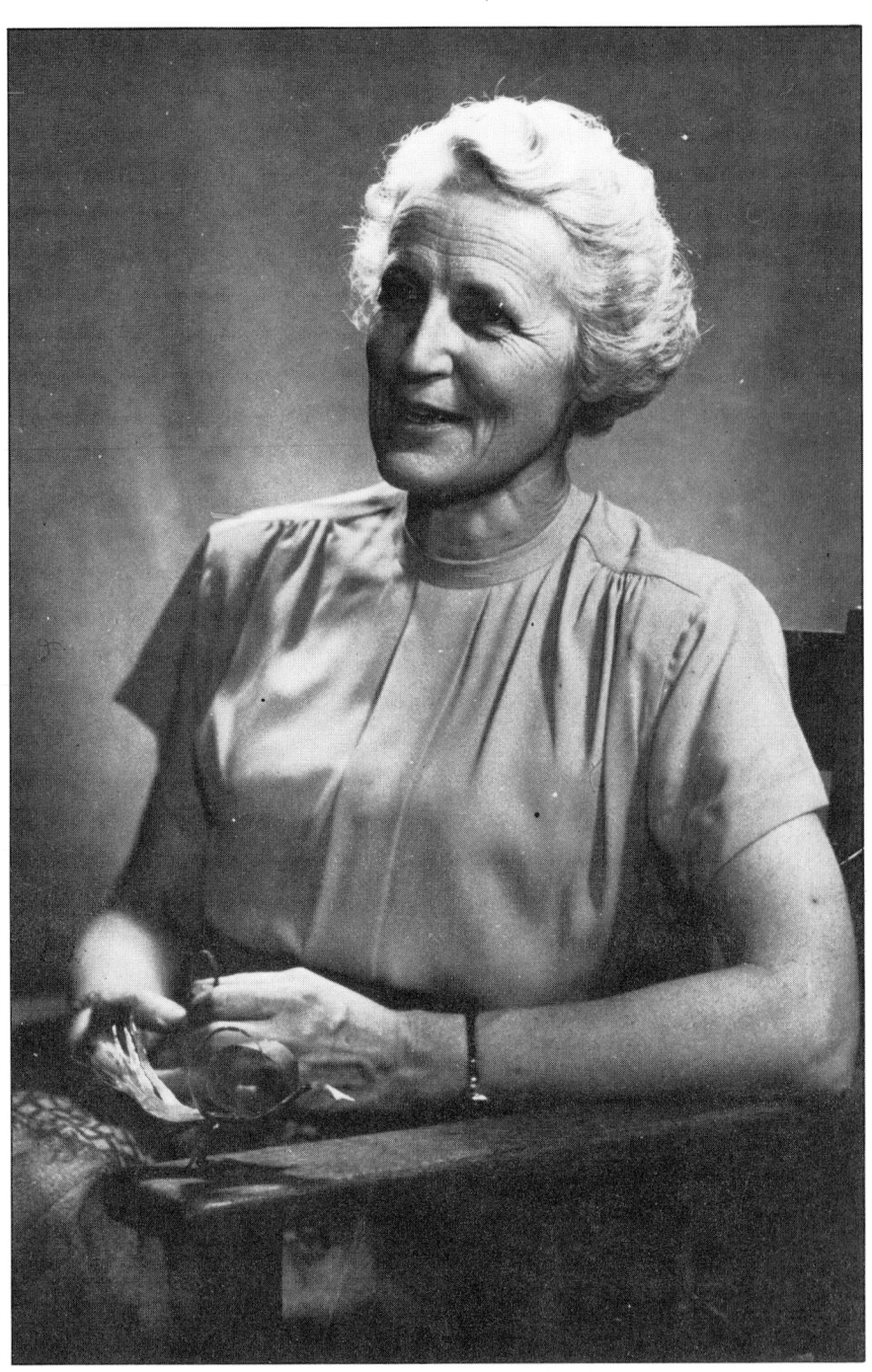

Anne Savage (1948)

Anne McDougall

Anne Savage:

The Story of a Canadian Painter

Harvest House
Montreal

For information, address Harvest House Ltd.
4795 St. Catherine St. W., Montreal
Quebec H3Z 2B9

DESIGN: Dreadnaught

Printed and bound in Canada

COVER ILLUSTRATION: "Cap à l'Aigle, Strawberry Pickers"
Courtesy of Concordia University, Sir George Williams University Fine Arts
Department
All of the paintings are from private collections except the following:
After Rain: Courtesy of The National Gallery of Canada, Ottawa;
William Brymner: Courtesy of The Art Gallery of Hamilton;
The Plough: Courtesy of The Montreal Museum of Fine Arts;
The Lake at Evening; Sundance Canyon; Untitled Sketches from Skeena, BC;
Cap à L'Aigle, Strawberry Pickers; Saint Sauveur; Early Apples, Wonish;
Northern Town, Banff; The Little Pool; Untitled, Métis; The Wheelbarrow:
Courtesy of the Slide Library, Fine Arts Department, Sir George Williams
Campus of Concordia University.

CANADIAN CATALOGUING IN PUBLICATION DATA

McDougall, Anne, 1926–
Anne Savage
ISBN 0-88772-182-6

1. Savage, Anne, 1896-1971. 2. Painters – Canada –
Biography. 1. Title.

ND249.S8M34 759.11 C77-000149-1

Contents

Acknowledgements

Many people helped me write this book and I'd like to thank them. Their names appear throughout the text. There would be no Anne Savage story without them.

Thanks of a special kind to the following: for advice, R.H.Hubbard, Dennis Reid and, in particular, Charles C.Hill of the National Gallery of Canada; Dean Alfred Pinsky and Mrs. Leah Sherman, Department of Fine Arts, Concordia University; Arthur Calvin, of Vancouver, who wrote a thesis for Concordia on Anne Savage's work; for help with new photographs, Karel Valenta, E & K Productions, Ottawa; for reproductions, Mrs. Alice Armstrong, National Gallery of Canada; K.Courtney, Art Gallery of Hamilton; Germain Lefèbvre, Montreal Museum of Fine Arts; for help with prints, Mrs. Anna Polgar Reich and Winston Cross of Concordia University; Mrs. L. van der Bellen, National Archives of Canada. And for their work in putting the book together, Susan Lash and Julie Kaufmann of Harvest House; Robert MacDonald and Deborah Barnett of Dreadnaught.

Finally I would like to thank Naomi Jackson Groves for her kind cooperation in making Jackson family material available.

To Rob

I
Starting in the Middle

It is Montreal in the mid-thirties. The table at 4090 Highland Avenue was really too big for tea. Years ago, when it had stood in an old country house, the same table had seated a family of eleven and with leaves added up to fifteen. It was still the most comfortable place to put the big silver tray, teapot, cream jug, hot water pot and sugarbowl with tongs. So Mrs. Savage sat here every day at four o'clock, and almost every day at teatime she was joined by neighbours and friends or, more likely, her own two daughters (one of whom lived at the other end of the same street) and their children.

The children sat still because they were allowed to "fish" for sugarlumps. The grownups took thin slices of brown bread and butter, or cinnamon toast from a hot bun warmer, or crispy oatmeal cookies. Men as well as women came to this tea party. It was relaxing and informal and stretched on 'til it was time to make dinner. Behind Mrs. Savage pots of ferns and begonias nodded against the French door that led into the tiny garden. In the winter lamps were lit and brown velvet curtains drawn.

In about the middle of tea, the front door opened and Anne Savage came home from school. The children ran to meet her, sure of a warm welcome in spite of the rush of cold air that followed her in. The woman who bent to kiss them was tall and poised and elegant, but by far the most striking thing about her was her smile, crinkle-eyed with pleasure at being home and finding the house full of people she loved. The children were faintly aware of a soft shiny black seal coat that held the cold and sometimes the snowflakes from her walk home from Cote des Neiges,

and heightened the colour in her rosy cheeks. For them her arrival lit up the entrance hall which, in winter, was crowded with galoshes alongside the old umbrella stand and brass barometer. She made teatime complete.

They went back to the cookies and she pulled off her hat and shed the parcels she hadn't already dropped to greet the children. These were the tools of her trade: armfuls of rolled-up drawings done by her art classes, sometimes a frame over her arm for a painting of her own. And then the paper bags, full of sticky buns bought at the bakery shops near the school where she taught.

Free at last, she checked the mail in the front hall. Sometimes there was a letter from out of town. When that was the case she found a reason for taking her things upstairs before going into the dining room for tea.

The letter she opened first came from A.Y. Jackson. If it was postmarked Toronto he would be writing from the Studio Building, the headquarters on Severn Street that imaginative men a few years earlier had turned into a painters' workshop for the Group of Seven. On a winter night when the light had faded and the day's painting was finished, Jackson would sit down surrounded by pots of turpentine, brushes, paints, and the canvas he was working on and scribble off notes to his friends.

On January 24, 1932, for instance, he wrote Anne Savage:

Dear Anne,
I intended to write you during the week but had a lot of correspondence about our forthcoming show in New York, meeting of the Group and pottering around.

Messed up a couple more canvases which will have to have a dose of paint remover

Your 'Plough' looks much better than it did in the Gallery, more intimate. Lismer said: 'Give that girl a chance and she would be one of the finest painters in Canada.'

Anne Savage ran a comb through her wavy hair, her mind far away. If Jackson and Lismer liked "The Plough" she would try to get some more work ready for the next exhibition. Her heart was singing as she ran down to tea. On her way downstairs she passed a large framed print. Men in red coats tumbled from rearing horses in an old-fashioned cavalry charge. Further along was a rogues' gallery of family photographs: brides in long trains, babies in christening robes. Not a modern painting in the house, except her own, which lay half finished, propped up against the wall in a corner of her room. These would have to wait for summer when school was out and she could pick up her brushes again.

As she went to join the family, however, the painter-teacher felt happy. At Baron Byng High School that day she had started the upper classes painting murals. Her mind leapt ahead to the day when the whole school library would be pannelled with their work. And now downstairs was a still younger set of children who loved her. Life was full and painting crowned it.

Anne Savage spent her life balancing the three elements: painting, teaching and family. She was an unusual artist who continually felt the excitement behind the phenomena surrounding her. When she wasn't trying to get this

down with her own paintbox, she was talking about art. She became an amazing performer whenever she shared this excitement. And yet when the show was over she insisted on no such drama for herself and went quietly home. It was at home that we knew her. Although as children we had no idea what "Aunt Annie" did beyond the heavy front doors of Highland Avenue, we often felt her bubbling sense of happiness and fulfillment when she came home after a good day's painting or teaching. In our early years she was not so much a distinct person as a presence in our lives. She created her own atmosphere; she made certain things exciting. Her way was unlike our grandmother's, which was serene and peaceful, or our own parents', demanding but more predictable. There was a kind of magic about Anne Savage. As children we knew there was something special about her. We were probably closer to it then than we would be for the rest of our lives.

Aunt Annie was a close aunt to six of us who grew up with her: myself, my brother and sister and three cousins. The house on Highland Avenue in Montreal and the lake in the Laurentians where she spent her summers were the two magnets around which our lives revolved.

But the professional Anne Savage was not the domestic one. At home, she was deep in family life. She lived and worked at a time when a handful of painters in Canada felt a new excitment about painting their own country. The men back from the First World War had found Canada unknown and in fact invisible in European art centres. They had a burning desire to "paint up," as they put it, the wild and tantalizing land they had fought for

but barely knew themselves. Their story of course is the story of the Group of Seven. Their work remains unique today.

Anne Savage's life is worth recording because she was not only a part of this painting renaissance but also an inspired art teacher who broke new ground in art education in this country. She did all this before the women's liberation movement was widely known and she had to face, at this early date, many of the questions being raised today.

During her lifetime, many who knew her tried to define her inspiration, her faith and the boundless energy that was her most attractive quality. A few years after she died I started to write about her; it was a precarious undertaking for a niece. Affection, memory, regret, and a new and rather awed awareness of what she had accomplished made it impossible for the family to tell her story clearly. Her pupils were eager to help, as were her painting friends. It only made the tributes weightier and the definition more difficult. I turned with gratitude to an interview taped with Anne Savage a few years before she died by an art student, Arthur Calvin, who was doing his MA thesis on her work. But Anne Savage had never been very good at blowing her own horn. Her musings in 1968 did little to bring back her real feelings about the twenties, thirties and forties.

And then in 1974 a basket of letters came to light that gave the story a new turn. Buried in an old chest in the cellar of the house on Highland Avenue, under a pile of photograph albums and folded curtains, was one of those

Ontario fruit baskets with "Prunes" marked in navy blue along the handle. Family documents in legal envelopes were tightly crammed along the sides, and down the centre ran a set of some 300 letters in small square envelopes addressed in the spiky scrawl of A.Y. Jackson.

The discovery of the correspondence jarred me. On checking with Naomi Jackson Groves, A.Y. Jackson's niece in Ottawa, I found that the other end of the correspondence also existed; there were letters from Anne Savage to A.Y. Jackson. There were far fewer of these, about 60 in all, Jackson having roamed the country for most of his life and lost many of his papers. Dr. Groves confirmed that A.Y. had stashed away more letters from Anne Savage than from any of his other numerous correspondents. Despite the gaps, for me the Jackson letters supplied the missing link. Here was correspondence between two artists, written during their most productive painting years.

The nature of the correspondence was sensitive. A senior established painter was writing to a woman fourteen years his junior, who was earning her living as a teacher and at the same time trying to make her mark as a painter. But the letters reveal no patronizing attitude on Jackson's part. The compliment in the letter quoted above is not typical of the way he wrote her. It contains, however, a reference to Arthur Lismer, who was to play an important part in Anne Savage's life and so it seemed a good one to begin with.

As for the secrecy on Anne Savage's part, that seems understandably feminine. What is more surprising is the fact that the letters survived at all. The basement underwent many tidying efforts before and after Anne's death.

These letters take us back to the days when a closed letter carried a three cent stamp, when mail delivery was so reliable that people depended on it to build their plans, when cars were few and people made rendezvous at train stations such as the big Toronto Union Station or the Windsor Station, steaming on a Montreal winter night.

The details of this life are all there: schools had big old clocks on the staircase; visual aids for teachers were few and things like lantern slides were handled with care; weather played a much bigger part in life when one couldn't hop from car to heated lobby and plans were cancelled by snowstorms; winter coats and rubbers were changed at a certain time of year for "spring coats," something hardly known in today's fashions. Magazines were different. *Saturday Night* ran in a big tabloid layout. Montreal had a pseudo-British snob publication called *Mayfair*. Roads were just opening up; a washboard track was paved in the forties and cars ventured on another twenty miles further north from what is today's populous St. Sauveur. Books, too, dated the times. A.Y. Jackson sent Anne Savage an early copy of *Jennie Lee*, *Lust for Life* and an early biography of Picasso. Schools had much less library material than today. Baron Byng High School rejoiced in a Carnegie donation of art prints. In these days, too, an A.Y. Jackson sketch could sometimes be bought for $35.00.

The painters' subject matter also reflects another period. When Anne Savage and other members of Montreal's Beaver Hall Hill group of painters painted Sherbrooke Street, it lay bathed pink and green in spring sunshine or silver and grey under a canopy of elms that have long since

vanished. Horses, sleighs and cabbies lined up in a regular row by the McGill University gates, something they now do rarely, and only for tourists. Streetcars, not terribly paintable, crawled by creaking with icicles. More lively were the children in Red River coats, red tuques and sashes, sliding and tunnelling down and through the huge snow-piles at almost every street corner. Montreal's church spires, convent gardens and tiny crèches have hung on. Today, they often look isolated. Gone is the fabric of old houses, turrets, interlocking laneways and rooftops. The downtown section of vintage Montreal used to have romantic streetlamps, candlelit French restaurants more tucked away than those found today, shining brass door-knobs up and down Crescent, Bishop, Mountain and Drummond Streets. The Ritz doorman was master su-preme of his territory on the evening of a big ball. These days have vanished into a canyon of useful highrises. But these days created the ambience and atmosphere from which Anne Savage and her friends drew their inspiration and which A.Y. returned to visit. Much of this early period comes through in these letters.

The Jackson letters also give, of course, a picture of earlier Toronto that will undoubtedly be put together one day. But Jackson was a native Montrealer and in this case he was writing to a Montreal friend. Between them they bring back the excitement of early discoveries in painting techniques, the thrill of sketching trips (though they rarely went together), in fact, the age-old delight for artists of each new generation, with perhaps one difference: the story that emerges from the letters of A.Y. Jackson and Anne Savage brings back some of the poignant and gutsy struggle of

painters who were just finding their feet in a society that barely accepted anything called "Canadian art." Like artists anywhere, anytime, they worked alone. But they had a passion which they shared and it drove them to keep in touch, to compare notes, to criticize each other's work. The passion was probably a love of their own country. It doesn't seem to have occurred to them to question what their country was. The main thing was to get it down in paint.

It has taken me some time to get a clear perspective on the correspondence between these two. What emerges is a long and lasting painters' friendship that ran for fifty years. If Jackson was the guiding spirit for much of Anne Savage's life and work, it is also true that she provided much of the inspiration at certain periods of his life. He once wrote her:

I'm going to put your letters away and keep them forever and ever . . . or anyway until 'the earth is old and the moon is cold and the books of judgment day unfold'.

This is not a book of judgment, or at least it's not meant to be. It's a look at an artist's life—Anne Savage's—from a point in time when what she did is history but what she loved hasn't changed. Painters are still searching out new ways of expressing what they feel. Going down new paths, they often feel out on a limb and call out to each other for help and encouragement. That is what Anne Savage and A.Y. Jackson did.

Because they lived at a time when people wrote letters rather than called each other long distance, we can share their story. If it happened today there would be nothing but

phone bills to show. But then if it happened today they might have grown closer than they did in the Victorian age they lived in.

The painter David Milne wrote: "Feeling is the power that drives art." Anne Savage discovered this the moment she began teaching art. Her direct approach with her pupils broke down for them the mystery that had always clung to art. Her own feelings were much more hidden. During her lifetime they were often hard to guess.

This is the story of one painter's life as she lived it. Her own paintings tell the rest.

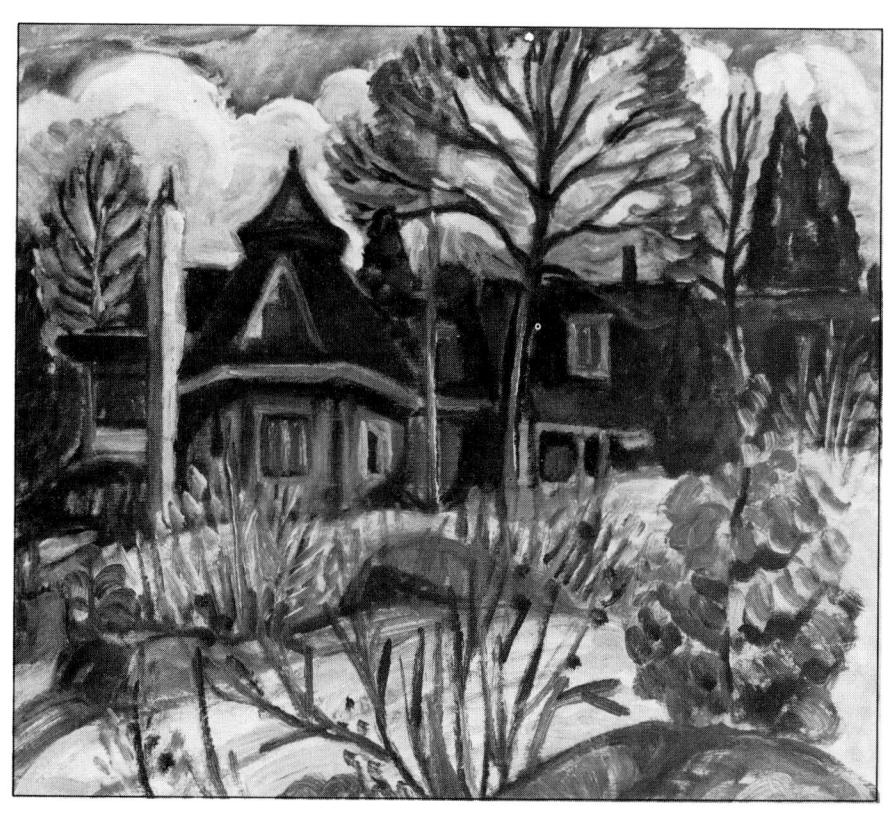

Kilmarnock (Wonish 1940's)

2
Early Days

While you were just a sweet little kid in school I was making history it seems...

AYJ to ADS, 10 November 1933

Anne Savage and her twin brother Donaldson were born in Montreal on July 27, 1896. She grew up in a big country house in Dorval just outside the city where her father, John George Savage, a Montreal businessman who would have probably done better as a farmer or real estate man, kept sheep, cows, horses, ponies and raised the youngest of his eleven children.

"Annie Douglas," as she was christened, was his ninth (or perhaps tenth). Donaldson was killed in the First World War. The name "Annie" was chosen for her father's favorite sister. It was to be an important decision for her when she signed her first pictures "Anne," almost a George Eliot move in the carefully polite, manners-ridden society she belonged to. The apparently miniscule change in name gave her a real sense of emancipation and daring. To artist friends, with one or two exceptions, she was never anything else. She often signed notes and sketches simply "ADS."

As "a sweet little kid in school," Anne Savage made the romantic trip morning and night by horse and carriage, or sleigh, from the Dorval house to the Dorval station, then by train to Montreal High School. As children we grew up on this story. There was a grey horse called Topsy with bells on his harness. The big dog Major and a little dachshund called Rut trotted behind the family, bundled under rugs. There was usually a moon over the snow as the sleigh whisked down the station road home to the lighted house. We heard all about the pony Bismarck and rides through the orchard. These were years of picnics under the trees, parties of little girls in stiffly starched dresses picking berries and a trip every spring to the

woods at the end of the property where trillium and dogtooth violet were picked in bunches for school and roots of hepatica and purple violets were carefully dug up and transplanted to the garden of their house "Elmridge."

In the background were the comings and goings of "the older family," J.G.Savage's children by his first marriage. Their mother had died when the youngest was four. As a widower, Savage met and fell in love with a gentle schoolteacher, Helen Lizars Galt, who was spending her summer holiday at Cacouna down the St. Lawrence. He persuaded her to leave her teaching job at Fredericton and take on a ready-made family. Within the next four years she had four children of her own. A nurse came in to give her a hand.

The table at Dorval stretched wider and wider with highchairs along the side. John Savage surveyed his brood with satisfaction. He was a warm-hearted patriarch, forthright, fond of sports and animals. He loved music, building houses and bundling the family off for trips. He was a staunch Presbyterian who sang out the old hymns lustily and believed what he was singing. His daughter Annie would not mark up as many bibles as he did, but she inherited his love of singing, heroic sayings and stirring couplets. They were all taught, of course, that it was not the game that mattered but how it was played.

By the time J.G.Savage's last four children arrived, he had a white beard and photos show an upright, pink-cheeked man, usually striding around in a tweed jacket, carrying a stick. His middle daughter Annie was often beside him but he seems to have loved them all dearly. His own journal survives. It is full of notes on the weather, the

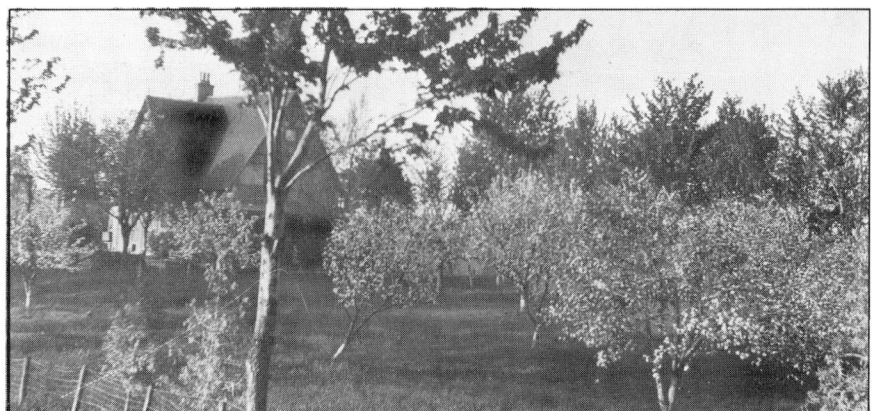

Orchards at Dorval
Orchards at Dorval
Elizabeth (Queenie) Savage

John G. Savage and Helen Galt Savage (1919)

state of the crops, the barn and the livestock at Dorval. He notes the family's movements: "Took the 5.20 out with Annie; Queenie [his youngest, christened Elizabeth but nicknamed after an Aunt Queen] coming later with Helen [the first daughter]. Lella [his wife] at Elmridge with Don who had a cold and missed school."

The entry on Don was not typical. He was by all accounts a strong boy, athletic, a young god in the eyes of his sisters and, as the only male in the household of women, the man his father was counting on to take care of them. In appearance he and Annie were quite different. She had a broad forehead, dark hair, snapping dark eyes. He had a narrower face, deep-set eyes and fairer hair, but the same kind of smile. Don had the slighter build when they were young but outstripped his sister later. She seems to have grown up as a bit of a tomboy and would say she felt like the sister Jo in *Little Women*.

There was always the sound of music in the big Dorval house. Anne Savage's half-sisters had trained voices and we always got the impression that they took singing rather seriously. She herself had a good voice and also learned the piano. As for painting, however, Anne would have had no guidance had it not been for Minnie Clark, her mother's sister. She often visited the farm at Dorval and, snug inside with her brushes and oils, would do snow scenes of the elms and maples and old barns through the window. Anne Savage would watch her by the hour and Mrs. Clark seems to have taught her three lessons: to look with her own eyes, get down the things all around her, and not touch another person's picture. Anne was to say later it left her longing **to paint**. It also showed her that a

Savage sisters and brother Don (1913)
'Elmridge' at Dorval

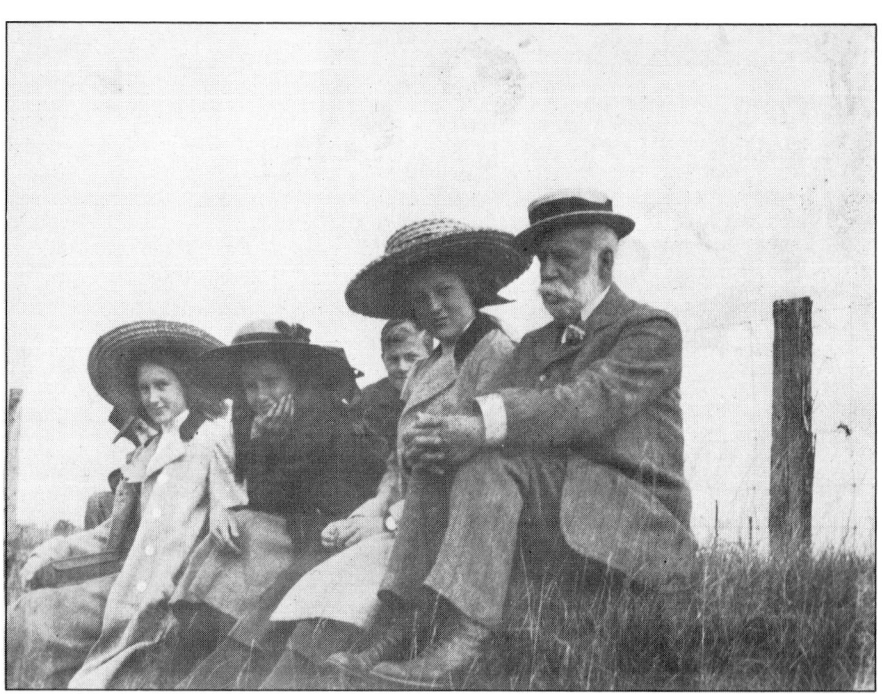

Helen, Annie and Queenie (1915)
J.G.Savage with daughters and friends at Lake Wonish (1912)

child not only can be, but sometimes needs to be led to an interest in painting. In the Dorval days, egged on by her younger sister, she spent every spare minute drawing. Her older sister Helen remembers this because it fell to her to sew dolls' clothes for the three of them. On Sunday, Mrs. Savage would read aloud from the classics. Annie spread her watercolours on the floor and painted the whole day long.

These early days on their own farm gave Anne Savage a love of the country she was never to lose and would in fact paint into almost everything she touched. Her father was not content with Dorval for the summers and took his family down the St. Lawrence "for sea air." He had been one of the first Montrealers to settle Métis Beach and as his older children grew up and married, many of them built their own white houses by the shore. His second set of children spent their earliest summers at Métis. As it got crowded J.G.Savage, in 1911, then in his seventies, set off north of Montreal to investigate a small lake on the old Canadian National Railway called Lake Wonish. It could only be reached by train in the early days and in fact boasted its own whistle stop on the CNR books even though it is only one mile from the next station, Sixteen Island Lake. For forty years after Savage bought the property, all equipment for Wonish was hauled in by freight train. Since then it has been reached by highway through St. Sauveur (20 miles away) and Morin Heights (8 miles) in one direction, and from Ottawa, to the west, and St. Jovite, to the north.

Mrs. Savage settled the four younger children into the wild bush camp over the summer months, gradually

putting in flower beds and a lawn, complete with croquet set. J.G.Savage encouraged his son, Don, to invite his friends and put up a tent. They were so often rained out that his father had a circular log house, designed like a tent with a tall pole through the centre, and called "Kilmarnock" after a favorite hymn, put up for him. His last son would never return to finish this house but a later generation growing up there have known "Uncle Don" almost as well as if he were still alive. Uncle Don's blue canoe rests on the rafters of the first house. Uncle Don's coats still hang in the hall. So lasting is his memory that for his sisters, and his twin in particular, time almost stopped at Lake Wonish when he was killed. Anne Savage may have spent the rest of her life trying to fill his place. Much of the clearing and building work has been carried on as J.G.Savage began it.

In spite of this work, the Laurentian woods still dominate the peaceful spot. The lake is small (3/4 of a mile long) and lies still and deep. Trout were stocked and the stocks fished out long ago. What remains is an unusual little valley where birds cluster on their trips south. An occasional red fox, racoon, groundhog or deer appears; the quiet of the forest casts a lovely hush and city dwellers gasp at the unaccustomed peace.

Anne Savage built her own studio at Wonish in the thirties at the head of the lake between the original "Horseshoe Cottage" and "Kilmarnock." It is a small house with the pitched roof and deep windows of an old Quebec farmhouse. In the front room there is a broad skylight cut into the ceiling to let in the north light. This was where we often ran and disturbed her as children and

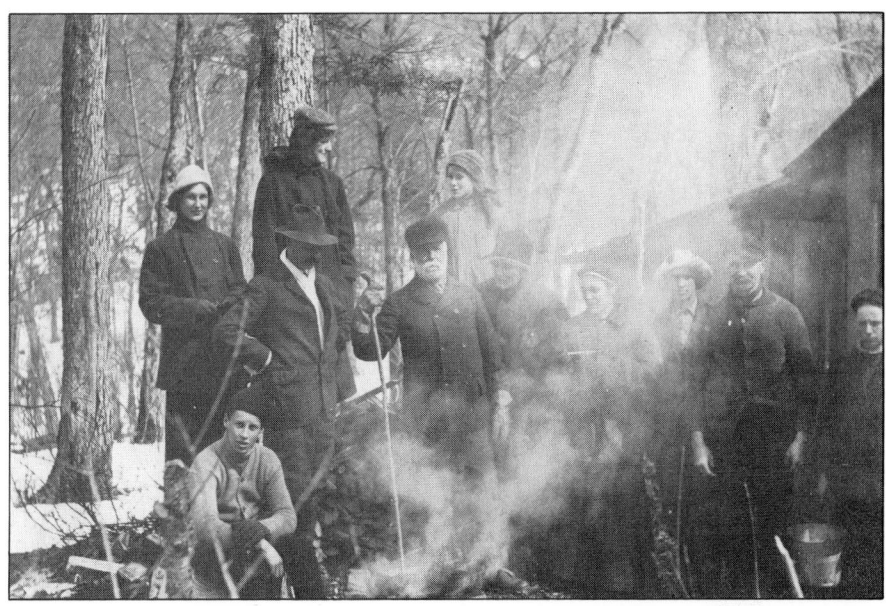

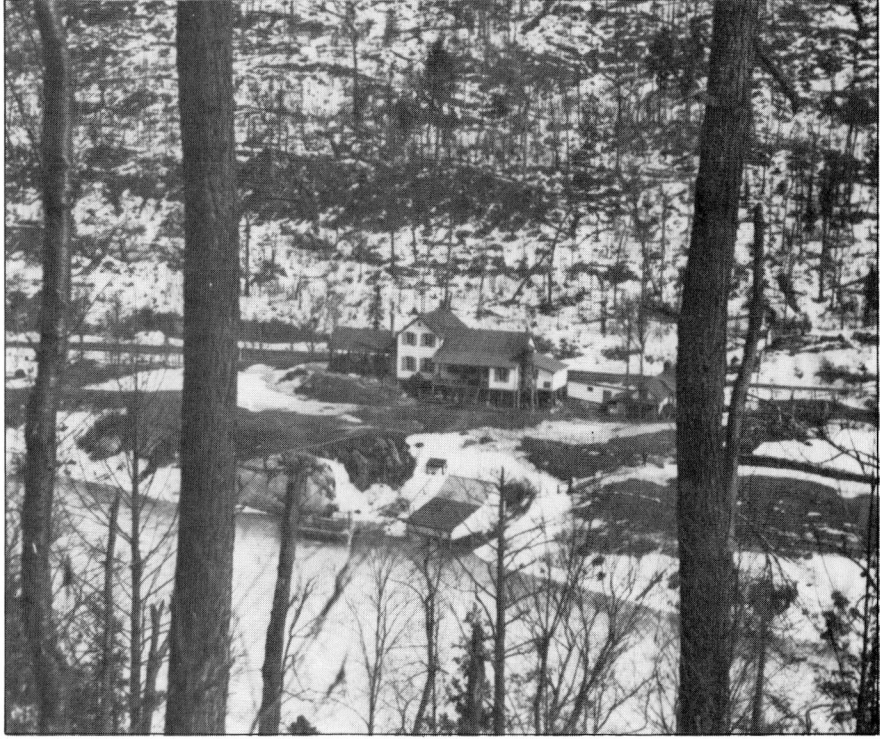

The Savage family and friends at a sugaring off (Wonish)
Lake Wonish

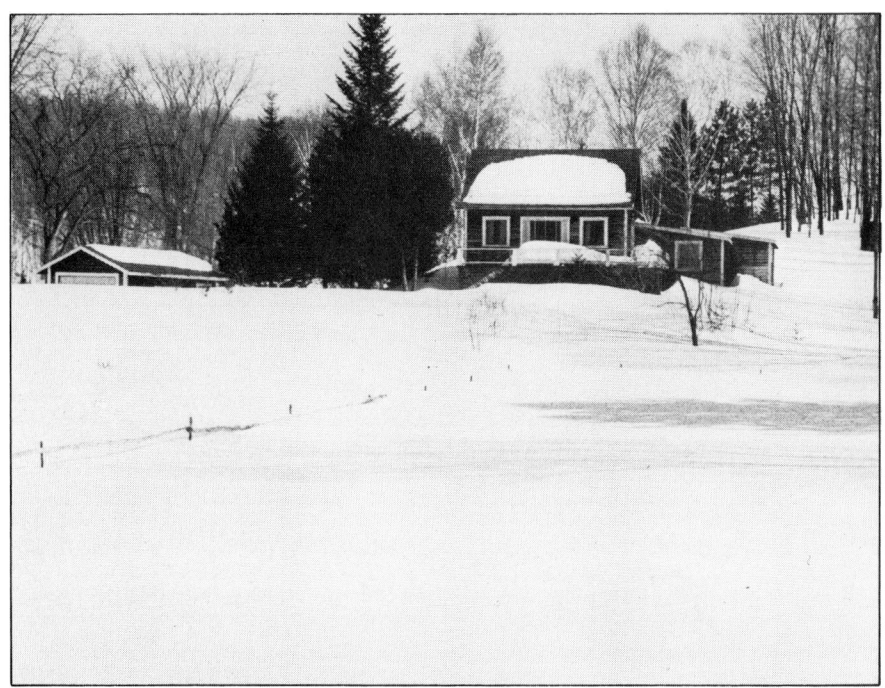

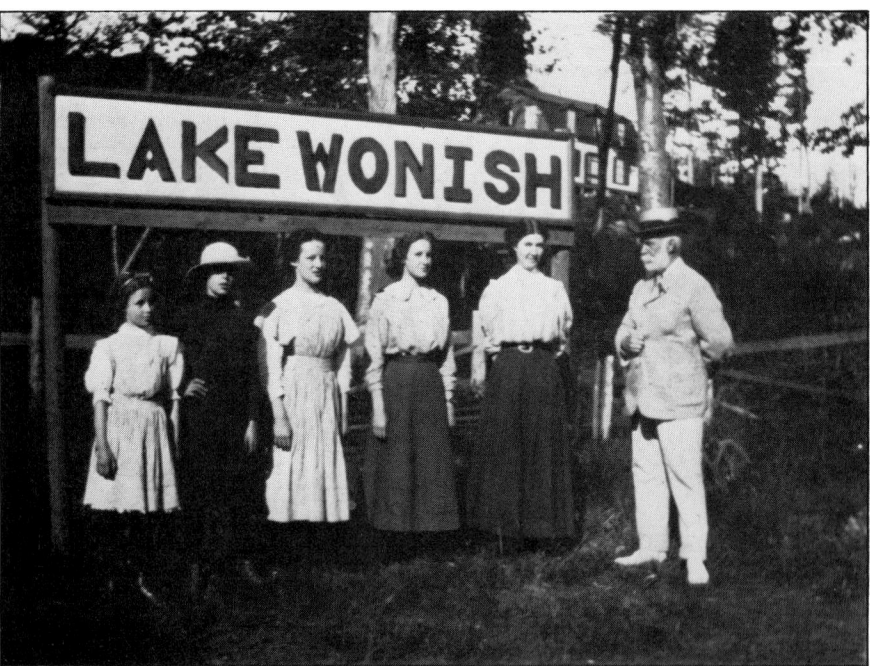

Anne Savage's studio at Wonish (built 1933)
Savage family and friends, Lake Wonish

she would give us lino cuts and show us how to make Chistmas cards all the time longing to get back to the painting on her easel. She went up to the lake at off-seasons, chiefly Easter and Thanksgiving. We couldn't get in her way then and she did some of her best sketches at those times. She looked upon Wonish as a haven, it may also have become a trap.

The First World War brought an end to the happy days of the Savage family. Don went overseas and was killed in 1916. His father felt the blow keenly, all the more so because his own business, Albert Soaps, had failed as a result of high wartime prices in perfume and oils, his raw materials. He sold the house at Dorval and moved the family into Montreal where they lived in apartments on McKay Street and Sherbrooke Street until he bought a house on a little street off Cote des Neiges called Highland Avenue.

J.G.Savage would not live long here but his second wife, who was seventeen years his junior, lived there until the end of her life. So did her second daughter Annie. It is a small, flat topped, two storey building, half brick, half stucco, with a big balcony across the front. Its attraction, as time went by, was its location. Situated on a cul-de-sac between the two mountains of Mount Royal and Westmount, it is away from traffic noise. The back garden faces onto an old-world lane and flowers from the row of houses spill over, spreading lilac, peonies, sumac and day lilies in profusion. Before Westmount mountain was developed for duplexes, the houses on Highland Avenue looked back onto a hillside of white birch, wild red columbine and, at one point, poison ivy. It remains today

a peaceful oasis in the middle of bustling Montreal.

By the time her father had moved to Highland Avenue, Anne Savage was at art school. At Montreal High School, she always said, she hated book work and only in art class felt the slightest degree of confidence. In spite of this, others remember her as quick and unselfconscious when asked to do any public speaking. She was the natural choice for class valedictorian. For the artist Anne Savage, however, growing up in a world of beautiful sisters and handsome boisterous brothers, drawing was the rock she clung to. When she graduated from high school she had formed a kind of future for herself.

In 1968 she talked to Arthur Calvin, a tall, reticent art student at Sir George Williams University, who was writing his MA thesis on her work. In that interview she sums up what she had only hinted at over the years:

I suppose this is a very personal thing. I had a twin brother and Don was clever as an engineer. He was going to be an engineer. He could draw but he couldn't draw as well as I could and so I was always correcting his drawings if there was something to be done. And the idea was that when I grew up I was going to be an artist and Don was going to be an engineer. However, in 1914 Don went to RMC and by 1916 he was dead and I was left with this feeling of trying to do something to make up for that loss and I think that was the basis of why I worked the way I did. That came at a very critical time and fired me to go on with what I was doing.

What she was doing was studying art at the Art Associa-

tion of Montreal, always called "The Gallery." Nora
Collyer, a Montreal painter, remembers her as "full of
life, with high colour and bright eyes and an infectious
sense of humour. She used to wear a red smock. When
Don died she came in wearing a black one."

There was another soldier in France at the time Anne's
brother was killed. Many years later, June 3, 1932,
A.Y.Jackson wrote her from the Studio Building in To-
ronto:

*I was just thinking back to another June 3rd crawling
along a trench in Sanctuary Wood, and an aeroplane
circling overhead like a big hawk, signalling to the
artillery who were trying to blow us up. It was a day of
glorious sunshine and only man was vile, in general,
individually they were magnificent. I thought a cup of
cocoa in a dressing station was an undreamed of luxury
and sixteen years have rolled on and I am writing to a girl
I knew nothing of then.*

At The Gallery Anne Savage studied under Canada's first
great art teacher, William Brymner, and the painter
Maurice Cullen. She became a skilled draughtsman and
early examples of her drawings show a pleasing sense of
line and space. She also did fine lettering.

From Cullen she got her first experience in sketching
outdoors. When he took the class on spring trips she was
thrilled. She remembered that he brought the Impres-
sionist influence to Canada, after spending time in Paris
with the Montreal expatriate painter J.W.Morrice. But,
said Anne, "Cullen might as well have thrown the new

ideas to the north wind. Canada wasn't a bit interested in them."

Cullen also, apparently, would grab a brush and put in a stroke to help a pupil with a problem. Anne remembers how it helped them and years later, Aunt Minnie notwithstanding, she was occasionally to do the same thing herself.

Brymner was a strong character and a lasting influence on anyone who studied under him. He never touched a painting. He would discuss it from an intellectual viewpoint. Although he didn't give formal lectures, she remembers that he somehow imparted a feeling of immense importance to the world of art. Or, as she says in the Calvin interview, "imbued" a feeling of importance. This kind of malapropism, or slight confusion of words, was something Anne did all her life. She was not as sure of letters as she was of paint. And yet she had an urge to express herself and forged ahead, often laughing outright at her own funny mistakes and inviting others to laugh too.

One day in class Brymner stopped in front of her painting and said: "One thing about you, you have a very fine colour sense," to which she replied rather cheekily: "Well that's a good thing." Brymner said: "You should thank the Lord on your knees for that. It's got nothing to do with you. You didn't work to get that."

Through Brymner the art class got to know the work of the British painter Constable, whom he admired, and also the Montreal painter J.W.Morrice, whom Brymner visited in Paris. Anne remembers their teacher at a Spring Exhibi-

tion: "With his cane, and heavy mustache, he had a noble bearing," she says. There was a crowd around a controversial picture by the Montrealer John Lyman and Brymner moved in to say: "If a man wants to paint a woman with green hair and red eyes he jolly well can," and stomped off.

One memorable day he came into the class and urged them to go downstairs to the Print Room where something unusual had happened. Anne remembers bounding down the stairs. It was the first time the Tom Thomson sketches had been shown. They had been hung rather surreptitiously so as not to offend the Gallery trustees, and they didn't hang for long. Just long enough to give the students an idea of what was coming. Anne Savage recalls: "And then slowly the men came back from the war and we met these people, A.Y.Jackson, Edwin Holgate, Randolph Hewton. We knew something exciting was going to happen in the painting field because it was a real nationalistic mission they were on."

The mission was to result in the Group of Seven. Their story is well known. Less well known is how their mission caught fire in Montreal. Anne Savage, the new graduate in art, was to be in the centre of it.

Bellvue Terrace (ink drawing)

3
Starting
to
Paint

Lismer and I were talking yesterday about the situation. Our gang broke away from the old Barbizon methods of the painters of 20 years ago. We emphasized the importance of our background.

AYJ to ADS, 11 October 1933

When she finished art school, Anne Savage thought she would be a full-time painter. The family business had failed in the war, however, and when her father died she went out to get a job.

She tried a number of things, such as medical drawing and lettering at the Military Hospital at Ste. Anne de Bellevue, followed by ten months at the Minneapolis School of Design, where she was assigned to draw dental charts for government records. She was happy in Minneapolis and often, later in her life, spoke out for what she found a generous, breezy attitude towards art in Americans. The charting was grim work, however, and she returned to do commercial art at Ronalds Press in Montreal. By this time she had toyed with the idea of going to New York to make her name in the big commercial art world. She had not yet become excited about painting Canada.

In 1921, however, after the Group of Seven was well established in Toronto, one of its most determined members came down to Montreal to see what could be done about organizing a related movement in that city. A.Y. Jackson had been born in Montreal in 1882 and although Montrealers had previously rejected his work (he didn't sell a painting in his 1911 show there) he had an abiding love for the city and kept returning to it after he had made his headquarters in Toronto. It is interesting that Jackson, who had made it his mission to replace the brown meadows and cows of old Europe with the empty grandeur of Canada's north country, should return in the spring of the year to the oldest established part of the country, the farm lands of early Quebec. In thirty years, he writes in *A*

Painter's Country, he missed only one season down the St. Lawrence. Passing through Montreal on his way to *"en bas Québec"* he would look up his old friends from art school days. On his way through he usually had with him about fifty panels, 8 1/2″ x 10 1/2″ birch boards. On his way back, with any luck, they had turned into sketches which he would use for his winter's canvases. Many place these sketches amongst Jackson's most impressive work.

This was when Anne Savage got to know the rugged, blue-eyed painter, fourteen years older than herself. His drive and singleness of purpose fascinated the younger painters, many of whom had grouped together by this time to share studio space and put on exhibitions.

The Montreal artists called themselves "The Beaver Hall Hill Group" after their new headquarters, a three storey building on the brink of Beaver Hall Hill just where the street dips down from Dorchester Boulevard to the financial district below. Now torn down, the building stood opposite what is today the Montreal headquarters of the Bell Telephone Company. It had a large open room downstairs for exhibitions and a few studio rooms upstairs, which artists used singly or shared. For some time the painter Randolph Hewton lived there. Anne Savage shared a studio with Nora Collyer, who had become a close friend in art school.

"Our shows weren't very grand affairs," says the portrait painter Lilias Newton. "We just asked a few friends in for a glass of sherry, sometimes not even that."

In January, 1921, the Montreal painters asked A.Y. Jackson to open their first show. He triumphantly introduced the members of Beaver Hall Hill as "a group of

artists and not an association of art, who are interested in developing individual talent, not mediocrity." Jackson had worked for seven years in France, after his early struggle in Montreal and then Chicago. He spoke fluent French. In his address he called upon French-Canadian artists to work with the Beaver Hall Hill group and told them about the group in Toronto, urging them to do for Quebec what the Group of Seven was doing for Northern Ontario.

An issue of *La Presse* (January 29, 1921) compared the twenty young Montreal artists to the Indépendants de Paris, noting that both groups wanted to paint their own way and break with the traditions of the past. The names are interesting: Mlle. Jeanne de Crèvecoeur, James Crockhart, Adrien Hébert, Henri Hébert, Randolph Hewton, Edwin Holgate, A.Y. Jackson, John Johnstone, Mabel Lockerby, Mabel H. May, Darrell Morrissey, Hall Ross Perrigard, Robert M. Pilot, Sybil (Sarah) Robertson, Anne Savage, Sheriff Scott, Regina Seiden, Thurstan Topham, Lilias Torrance. Prudence Heward was also a member of this group. Edwin Holgate, who was to join the Group of Seven in its later days, was the unofficial leader of the Montreal group.

And so the friendship between A.Y. Jackson and Anne Savage began. Nora Collyer, today a gentle, slipper-thin woman who still does an occasional painting from her home on Elm Avenue, looks back and says: "Yes we all knew Alec; we thought of him as much older. He used to come back to Montreal after he moved to Toronto and show us his sketches. We would have a party at his brother's house, (the lithographer, H.A.C. Jackson) or Prue Heward's, or the Robertson's, and he would put up his

latest work, wherever he had been, down the St. Lawrence, up north. If we liked one we'd put our name on the back. If he didn't need it to enlarge into a canvas, or after he'd done the canvas, he'd sell it to us for $35.00."

In the years that followed, A.Y. kept up his friendship with many of the Montrealers, encouraging them and helping with arrangements for exhibitions of their work. In 1925, for example, Anne Savage visited Toronto where she spent several months working with Arthur Lismer at the Ontario College of Art. It was for her a sort of pilgrimage to the world of "real art." On June 7, 1925, she wrote to "Dear Alex":

I was awfully glad to get your letter I am looking forward to my visit very much. It will be the greatest delight and privilege to meet real people in the art world and see how they do things.

Our little exhibit at the Gallery seemed to hold its own. . . . It's most awfully good of you to give me the freedom of your studio. That should inspire some effort. Please don't shine it up and whatever you do don't clear anything out. I'll go down and have a feast every now and then.

Sincerely,

Anne

It was on this trip, she told Arthur Calvin, that she marvelled at the scope and orderliness of Lawren Harris' studio where paints, brushes and canvases were stacked and labelled in perfect array. She said:

He pulled out the drawers and there were his brushes as streamlined as a scientific laboratory. He had a heavy black easel. He showed me panels of Lake Superior with huge black stems of trees and a definite feeling of dignity and control. There was nothing out of place. I remember thinking isn't this extraordinary and couldn't analyse it. But after I came back I realized he was abstracting his subject. He was on his way to just shooting off into this world of nothing but light and air.

At the very beginning of her own painting life, she immediately recognized in others the creative spark that lived in her all her life, but which sometimes left her unsure of which way to turn.

Her paintings at this time, like those of the others in the Beaver Hall group, show the influence of the Impressionists, an influence which Morrice and others had brought late to Canada but which was considered very much avant-garde in households still hanging copies of old European masters — "the Dutch gravy school," Jackson called them.

Anne Savage sought light and rhythm and had a sure hand with a purple shadow beneath a bank or a burnt umber across a sunlit hayfield. She did an interesting picture shortly after her brother's death. It is medium-sized, 24" x 20". The colour scheme is mauve and lavender and the subject matter a composition of willowy tree trunks each capped by a wide, whimsical, asymmetrical, balloon-shaped whirl of foliage, also mauve-lavender. The effect is a fantasy land. It has great beauty and also sadness. A.Y. Jackson saw the picture in the twenties and joked:

"The trees look like greyhounds on stilts."

These were the years when she showed a joyful, fearless use of colour. "The Red House, Dorval," painted in 1928, is a severe simplification of a rosy-crimson, steep roofed house, standing on a corner behind two tall, stark black trees. White snowbanks complete the composition. The trees are stylized, almost like a poster, and are painted flat, without depth of shadow in the trunks or branches. And yet the painting has a rhythm that does not become monotonous and is warmed by the red tones.

The inspiration behind her paintings resembles poetical inspiration, especially Shelley's. Her best pictures spring from a love of colour or strong feelings about something that happened in her day-to-day life, perhaps a visitor that gave a lift to an afternoon or a family party at her studio. When she was inspired by a crowd of people skating on the mountain, however, or an exciting play, or a tableau of mothers and children on Highland Avenue, she does not people her pictures with human beings, as Pegi Nicol did, but turns again to landscape and throws the joy into a sweeping tree or bank.

Her best pictures are a cry for beauty. At her best she has a natural grace and expansiveness as seen in an early canvas, "April in the Laurentians." There is a sunny benign quality to the painting. Louis Muhlstock, reminiscing from his studio on St. Famille street in the French neighbourhood where Anne Savage loved to visit him, says: "Anne was a happy person; you can see it in all her pictures." Sometimes this deteriorates to a "Pollyanna" emptiness which crept in when her enthusiasm flagged.

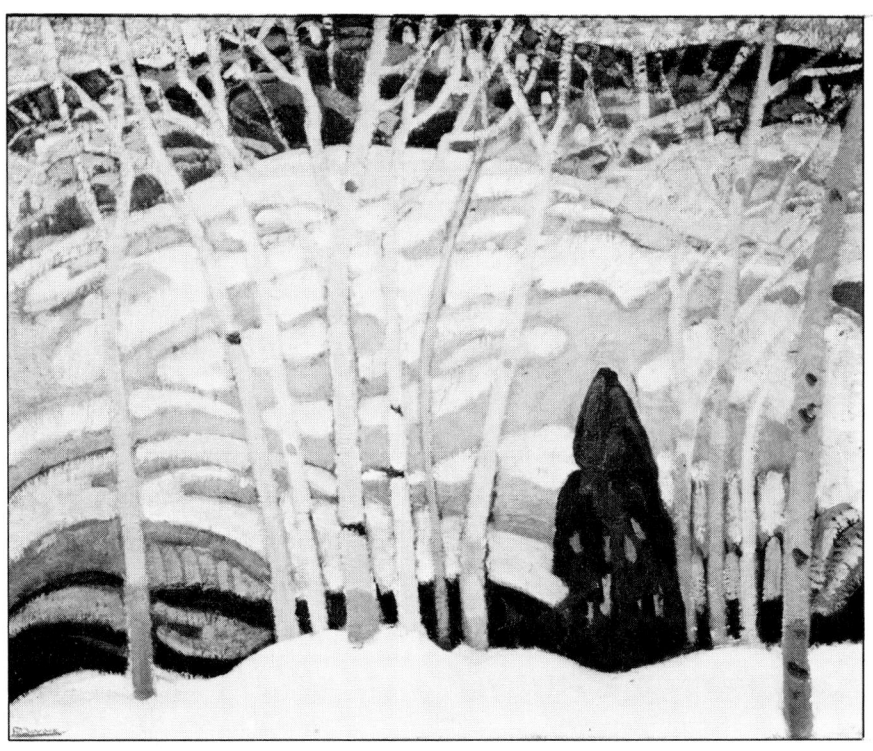

April in the Laurentians (early 1930's)

While the men in the Group of Seven were tracking the hills of Lake Superior, camping and roughing it among flaming maples and the desolate scrub of the north, the women of Montreal were painting, naturally enough, much gentler things: interiors with glimpses of the old city through a window, flower studies, Sherbrooke Street through a grey mist with the horses and calèches drawn up in a row, the rolling yellow and mauve hills of the Eastern Townships, blue and white Quebec villages, and Laurentian spruce and clumps of elm.

If you put paintings by Anne Savage, Emily Coonan, Prudence Heward, Sarah Robertson, Mabel H. May, Mabel Lockerby, Nora Collyer, Lilias Torrance Newton, Ethel Seath and Kay Morris all together you get a "Montreal look." It is a look of colour and mood; much of it comes from the French details: outside staircases, wide balconies, nuns strolling in a convent garden, baskets of pink geraniums, a wayside shrine. It is a look quite different from anything else painted in Canada. These artists were exhibited by the National Gallery in 1960 in a show called "The Beaver Hall Hill Group," organized by Norah McCullough, a former assistant to Arthur Lismer.

The group lasted officially only four years and put on only five shows of their own. They were like a flurry of bright butterflies settling on a rock for a brief time, then off on their own ways. Edwin Holgate thinks it is a Montreal characteristic that soon took these painters down their own paths to find their own techniques and to develop more independently than their Toronto counterparts, who found stimulus and commercial advantage in getting together.

As it happened, the men among the Montrealers didn't

have either the interest or talent for organization that A.Y. Jackson in Toronto had. Holgate says he would go off sketching with Clarence Gagnon, Albert Robinson (the Hamilton painter who liked to paint the lower St. Lawrence) and sometimes A.Y. himself. But when it came to getting hold of canvases for exhibition, with all the details involved, none of the Montreal painters stepped forward and A.Y. took it on. The result was that Jackson worked for years with a group of women in Montreal. Probably, as a younger painter, Jacques de Tonnancour was to say, he preferred it that way: "one rooster in a hen-yard you know." It means Jackson had a far-reaching influence on Canadian art in Montreal as well as Toronto during the twenties, thirties and forties, not necessarily through possessiveness but simply through hard work.

Although the Beaver Hall painters didn't form a very long-lasting bloc, they were impressive in the strength and variety of their styles. Holgate himself was to leave Montreal, first for Paris and then to live in the Laurentians. Randolph Hewton ran a commercial business. The women maintained a surprisingly professional attitude. In an era when proper young ladies were expected to pick up an embroidery needle before a paint brush (and neither on Sundays), these painters were never amateurish. Over the years they built up a substantial body of work now recognized as representative of the best of that period. Alfred Pinsky, head of the Fine Arts Department of Sir George Williams University, refers to their special quality and says it was unusual to have a group of women painters of that stature.

"I don't know if you would call them great," he says,

Concarneau (pencil sketch, 1920)

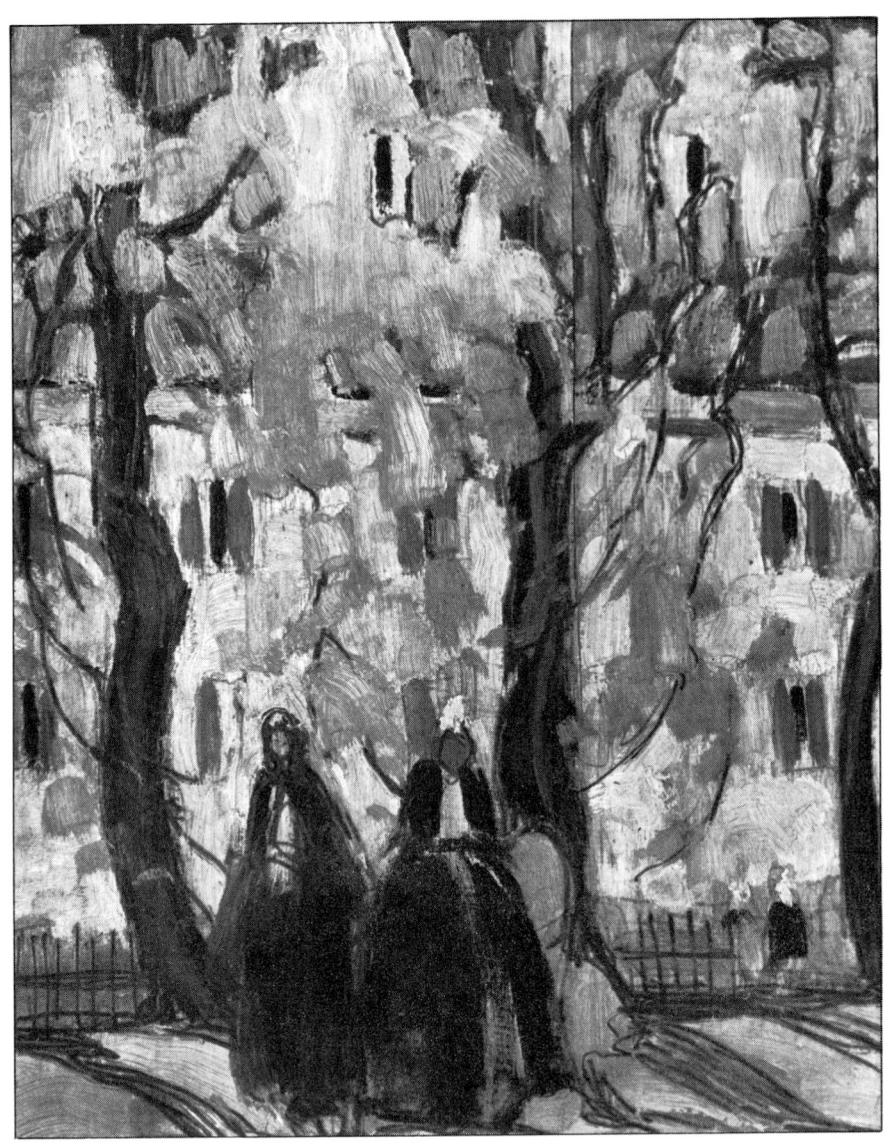

Square at Concarneau (Brittany, 1920)

"but they're all damned good painters." He adds: "All those English-Canadian girls were suffering from a society life that convinced them women painters were not real painters. It was a central conflict of the Beaver Hall group. Anne Savage was caught between considering art as decoration to life or as a driving force, which she knew it to be."

Her early pictures have a simplicity that some were to find too poster-like. Many have a quality of *art nouveau*. But Gerald Trottier, a modern Ottawa painter, attended a private showing of her paintings, and he passed up her later work in favor of an earlier canvas he found more interesting: a small sketch in oils of the Square at Concarneau in Britanny, done in 1920, in which she abstracts blocks of colour behind a frieze of black trees with two figures in the foreground. The figures play a distinct role in the painting. Rather than pursue this tack, however, she abandoned figures, as a direct result of the Group of Seven influence.

Pinsky says rhythm was a key element in her painting, along with "a sweet sense of design" and strong colour sense. "One thing Savage knows almost to a point of perfection is the relationship between colours that are muted. She can take a pink and a green and muted yellow ochre and bring them into a harmony which is quite remarkable." He compares her oranges and greens with early Italian painting and says her personality tended in that direction too, as gentle as the tints she used.

Both her sisters remember her passion for painting. Up in the country she would fly out of the house, her hair tied up in a scarf, and get out in the canoe in the pouring rain

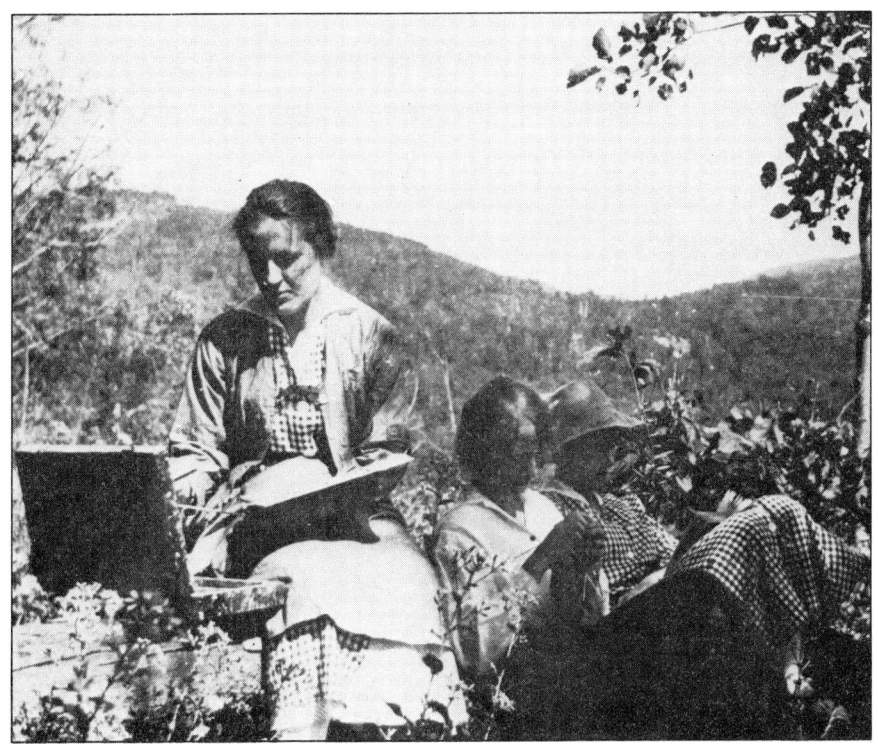

Anne Savage, Ruth Abbot and Helen Savage at Lake Wonish (1916 or 1917)

to finish a picture she had started on the lake, no matter who tried to stop her. It was not a hobby; it was a compulsion. In another woman it might express itself in an obsession to buy and sew beautiful fabric.

Nora Collyer remembers the exhilaration of getting their work shown. She notes that many of Brymner's pupils were accepted for the Montreal shows at an early age. Anne Savage had a picture in the Spring Show in 1918, when she was just twenty-two. They almost took it for granted after a while that they would be shown. Selling was another matter and at first not very important. Nora Collyer says they didn't know what price to mark on the canvases and Mr. Brymner told them: "Anything worth hanging is worth $5.00." It wasn't many years before the wave of abstract art broke over the painting world in Canada and the "radicals" of the twenties and thirties were swamped by more experimental painters. Many of the Beaver Hall painters had to wait some years until their art came back into vogue.

Anne Savage with a boy's class,
Baron Byng High School

4
Learning to Teach

Art is an activity that mediates between the inner and outer worlds of reality and only through its creative force can we secure in the child "A heart prepar'd, that fears no ill to come."

Put into their hands and fingers what they can find of truth and beauty... to produce an undivided self.

Sir Herbert Read: on "The Significance of Childrens Art" UBC lectures, 1957

In 1922, when the Beaver Hall Hill group was in its second year of existence, Anne Savage got a phone call that changed her life. Dr. H.J.Silver, head of the Protestant Schools in Montreal, rang to ask if she would come in as a supply teacher for the Commercial and Technical High School. She had had no teacher training whatever. Later, to Arthur Calvin, she told a story of her first days at school.

Every morning from eleven to twelve she found she had a spare period and so would pack up, punch the clock, walk out and do her shopping. The principal watched this for the first week and asked her what she was doing. Thinking it was her own time and she could do what she liked she listened surprised when he explained that she was supposed to use this time to get ready for the next period.

So started the career that was to take her away from her own easel and send dozens of others to theirs. No one knows whether she might have painted more or better if she had gone at it full time. What really happened was that she came to love what she thought she had to do, and everyone who knew her later had no doubt that when she was operating in top gear in her art room, Anne Savage found as much joy and love as she gave. In the beginning she set out each morning, often she said with her heart in her mouth, to learn to teach art. Far from her thoughts was any idea of painting Canada. She was just concerned about getting through the next day. If she was anxious she did not show it. She was tall and carried herself proudly, not from conceit but because her father had taught her to. More important, she was candid about problems that were new to her and laughed at her own mistakes in a way that disarmed any critical colleague.

In that same year, Baron Byng High School opened on St. Urbain street; and Anne Savage was transferred to become the new school's first art teacher. Baron Byng was a complicated place to reach before buses were put in to skirt Mount Royal. She could never have guessed at the beginning how many times she would make the trip. There are neighbours still living on Highland Avenue who re- member her setting out for school. She left the brown doorway of her own house, stepped quickly across the street and swung past a big tree that marks the opening of a path leading to a shortcut to Cote des Neiges. On Cote des Neiges she would take the Number 65 streetcar downtown and then transfer north again on a Rachel car to the stop opposite Baron Byng. On bright days, she would skip the long streetcar ride and walk across the mountain. Eventu- ally she drove along Pine Avenue. When she was taking the shortcut from Highland to Cote des Neiges she walked under the balconies of a courtyard of houses where Arthur Calvin was born. They never met until he came to interview her forty years later. She told him then that the Protestant Schoolboard had had the choice of buying the lot facing Fletcher's Field for the new Baron Byng school but saved money by getting a back lot. Always interested in the visual side of things, she regretted the sheds and back alleyways that they looked onto and used to take her students out to Fletcher's Field to sketch. It was to become a noteworthy school despite its location, chiefly because the children who went there were first-generation Canadians whose parents had fled the Jewish ghettos in Europe. They were hungry for knowledge and, if not especially crazy about school itself, eager to get ahead. This was the world of Mordecai

Richler's *The Apprenticeship of Duddy Kravitz.*

The other side of that coin, however, were the parents of Baron Byng students, people who revered anything of the soul and spirit that reminded them of the old country. When these children turned up for art class or music class they did so with their whole heart. Anne Savage, art teacher, and D. M. Herbert, the choirmaster, had classes of some of the most vital kids in Montreal. She was to say later: "I don't think the Anglo-Saxons have anything like the emotional drive the Jewish people do. We had good material to work with, no doubt about it. We lived in a wonderful period; there were so many clever and talented children there – very, very able."

The retired mathematics teacher, A. Saunders, whose own pupils were topping the province's matriculation lists, gives another view. "She was an exceptional person," he says, "and would have got good results whatever the neighbourhood, or time, or kids."

She was fortunate that her principal was Dr. John Astbury, a strict, fair-minded Nova Scotian. He had had a sister who was an artist and who had died in the Halifax explosion of 1917. As a young boy he had made her frames. He was predisposed to support any art teacher under his charge. Anne Savage got a free hand. She said she didn't realize until later what it meant to have such backing.

She was a good-looking teacher. To the students she was first and foremost "different." They found her beautiful and original in her painter's smocks. "She wore a different one every day," recalls the painter Tobie Steinhouse. Some years later she used to dash off in a short, crimson bouclé

jacket and grey skirt. She had a graceful figure and lovely carriage and a sort of careless way of wearing clothes which looked pretty but not fussed over. She took care of her hair which turned from dark brown to silver grey in her twenties. It was shiny and wavy and often wind-blown. She was one woman whose appearance was almost spoiled when she had to wear glasses. They gave her a severity that wasn't justified and spoiled her open countenance and easy way of laughing.

She launched into teaching with a great deal of verve and energy. G. R. McCall, a friend from those days, remembers "she was wrapped up in that school." Although A.Y. Jackson wrote time and again: "You shouldn't be shut up in school all day, Anne, it's all wrong," Alfred Pinsky, who went to Baron Byng in the thirties, probably comes nearer the truth when he says: "We were all sort of in love with her . . . and through her had a love affair with art. I felt she had born me into the creative world."

She taught from the eighth grade right through high school. She ran her art room as she liked. She made what were at the time revolutionary changes by pushing back the conventional desks and chairs and clearing the centre of the room for a display table. The idea was to get the students drawing and painting freely and stop the old methods of tracing and copying other people's work. She had no "new method" but worked instinctively, basing her teaching on her own discoveries as a painter and remembering her own search as a child. Pinsky remembers: "She would give us a subject to motivate us and dance in front of the class waving her hands trying to express herself, but mostly it was her voice. She had a way

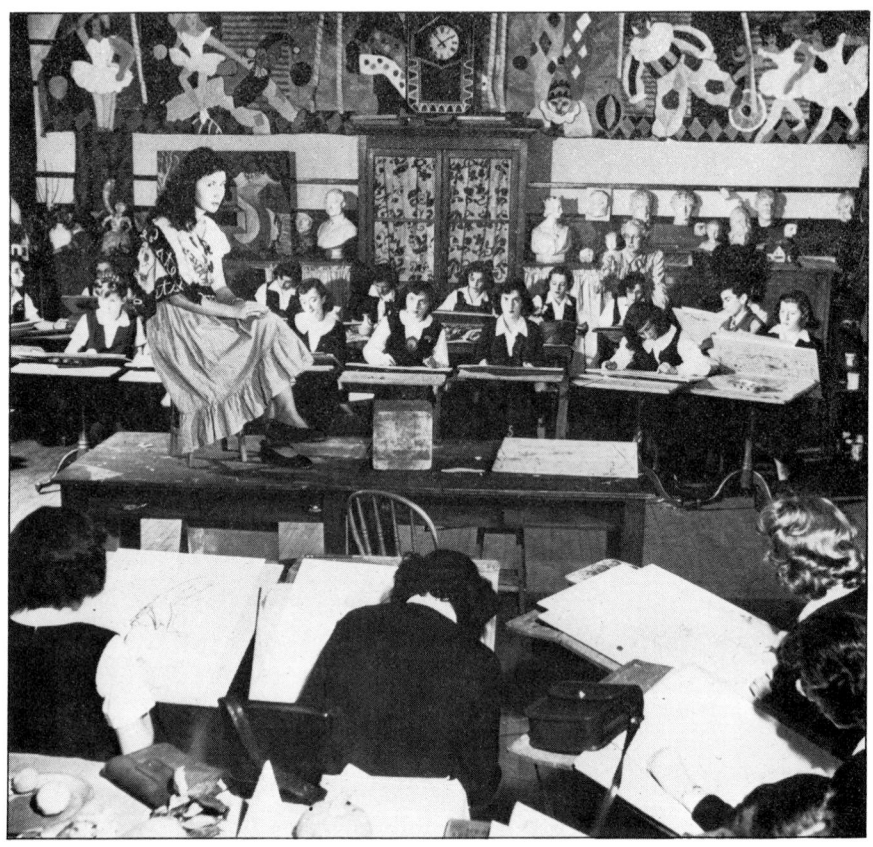

One of Anne Savage's art classes at Baron Byng

of speaking which sometimes rose into the higher oc-
taves. We used to mimic her on occasion. All these things
came together. Although the environment was permis-
sive she wanted results, and we wanted to give them to
her." She had the blackboards covered with beaver-
boards so the work could go up and students could help
by criticizing each other's efforts. Then she got them
painting panels to decorate their own school. It became a
sort of model, visited by other teachers. Some of the
panels remain to this day. The Home Economics room
carries a wide, panoramic village scene, with spires and
rooftops, done in what are now rather faded blues, yel-
lows and reds, running along the length of one entire
wall. It casts a serene atmosphere over the frantic activity
among the pots and pans.

From the beginning Anne Savage shared with her stu-
dents the excitement of sketching outdoors. She couldn't
go far afield in the early days and of course the high school
students didn't have oil paints. But with pencils, charcoal
and sketchpads they would set out, delighted to leave the
big concrete school for a while.

The east end of Montreal rolled by with all the colour
and striving and racket of New York's Lower East Side.
Tram cars, pushcarts, women in black shawls, old men
with long white hair and beards, young mothers in ban-
danas with babies in their arms, all passed by. The women
were on their way to the market "on the Main" looking for
food from home. There they found open stalls of oranges,
artichokes, eggplants, square gallons of olive oil, and
barrels of black olives covered with burlap, to remind them
of Poland, Greece and Italy.

The Baron Byng students didn't get to sketch this life;

they never would have returned to the school! Their
teacher headed them west from St. Urbain Street over to
Park Avenue which runs alongside big, open Fletcher's
Field. She remembers "the lovely avenue of trees going
from the Monument back to Rachel Street." They would
draw the trees. With the boys she sometimes made an even
more daring expedition to the Cemetery. She told Arthur
Calvin:

*It was a nice place and easy to get to and nobody was
there! We could sit on the tombstones and discuss what
was good taste and bad taste and how they would like to
take the iron off that and just leave the plain Gothic stone.
It was the beginning of getting to know how to paint the
outdoor world.*

As for school life, she fitted in well at the long table in the
staff lunchroom, taking her own apple or pear, hard-boiled
egg and cheese from home. She would spend the balance of
the lunch hour in the art room. Students could come in
and work on their projects. It was a happy place. Leah
Sherman, today a professor of art at Sir George Williams
University, was once a pupil of Anne Savage's and her
successor as art teacher at Baron Byng. For her, as for many
others, the art room was a refuge. It was sometimes left
open after school for a while with a student in charge.

For her own development as a teacher, however, Anne
Savage had to look further afield. She apparently realized
this from the start. She sent off some of the Baron Byng
work to the College of Art in Toronto and got in reply this
encouraging letter from another art teacher, Arthur

Lismer, already well established as a teachers' teacher and getting ready to set up the Children's Art Centre at the Toronto Art Gallery. On August 11, 1922, he wrote:

Dear Miss Savage,

Pardon my apparent neglect in not replying to your letter and the parcel of drawings you sent. I have had them on exhibition in the College during our Teachers' Summer Course in Art, just concluded.

There is no doubt that your methods are proving successful. I think the work admirable. Any class that can produce such work proves the ability and enthusiasm of the instructress, for one can only get out of a class that which one puts into it. Results return to one in a way unbelievably stimulating, demonstrating convincingly that the teacher has to be the aesthetic inspiration for the student. Few people recognize this as yet. The colour work is splendid and the grouping of objects admirable. There is a delightful childlike quality to the imaginative illustrations that only a woman's sensitiveness — and a painter's at that — can inspire. My own efforts seem rather matter-of-fact after seeing yours.

I must confess I'd like to see more actual drawing attempted but perhaps I'm over-estimating the kind of work you are asking from your pupils. Personally, in teaching drawing to youngsters I make an effort to give them as much experience as possible in visualizing form, but also in being able to present it in three dimensions and I've had some good results in drawing from life, from models; by showing them how to present the "volume" of an object or figure, tree, or bird form, etc., movement and

action first, proportion and solidity next, they soon realize that an object or figure has length, breadth and thickness and gives the appearance of height and texture to their work. I'm trying to do this with colour now.

We have had a wonderful time with the Ontario teachers recently. I'm going to send you a batch of their work soon so you can see what we do with them after only 20 days teaching. The result is amazing. It needs people with vision to put it through – and we needn't be ashamed to own up to having a little – painters make excellent teachers once the idea of giving out the things they know grips them. I've had four members of the Group of Seven on my staff this summer and we have given them the course in a thoroughly modern way. We have had 250 people to deal with and they all go away with something in them they didn't realize before.

For one thing they realize more fully the beauty of the objective world, and they know that although the artist is living in a world of imagination, he is using a tremendous organizing faculty to bring forth his outlook, to make vivid his impressions, and that organizing faculty is in itself a great educational factor

I enjoy so much receiving your letters and seeing your work. It's a great incentive to effort.

With best wishes,
Yours sincerely,
Arthur Lismer

One way or another, Baron Byng got a lot of attention from the Group of Seven. Through her own imagination, Anne was to inspire some remarkable work which was to

of a Canadian Painter

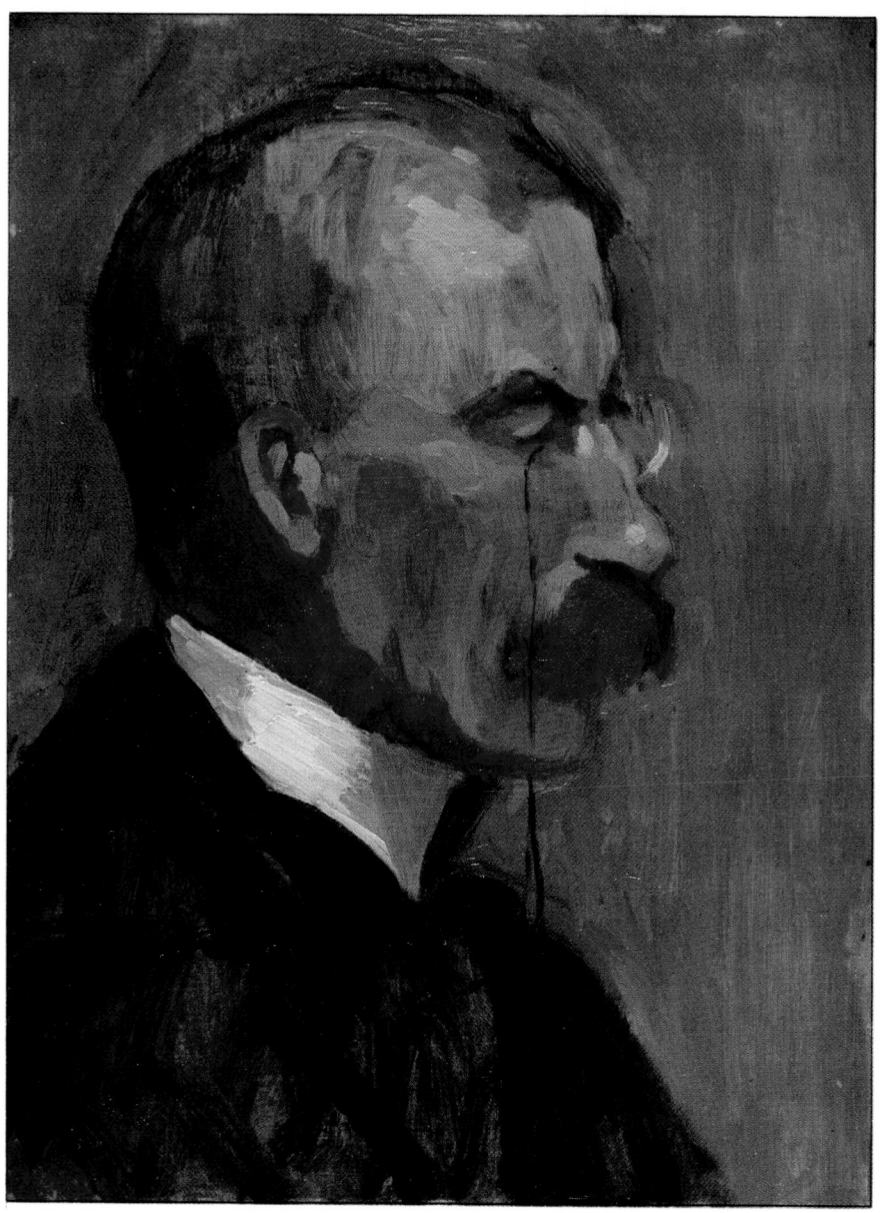

William Brymner (1918)

Anne Savage: Story

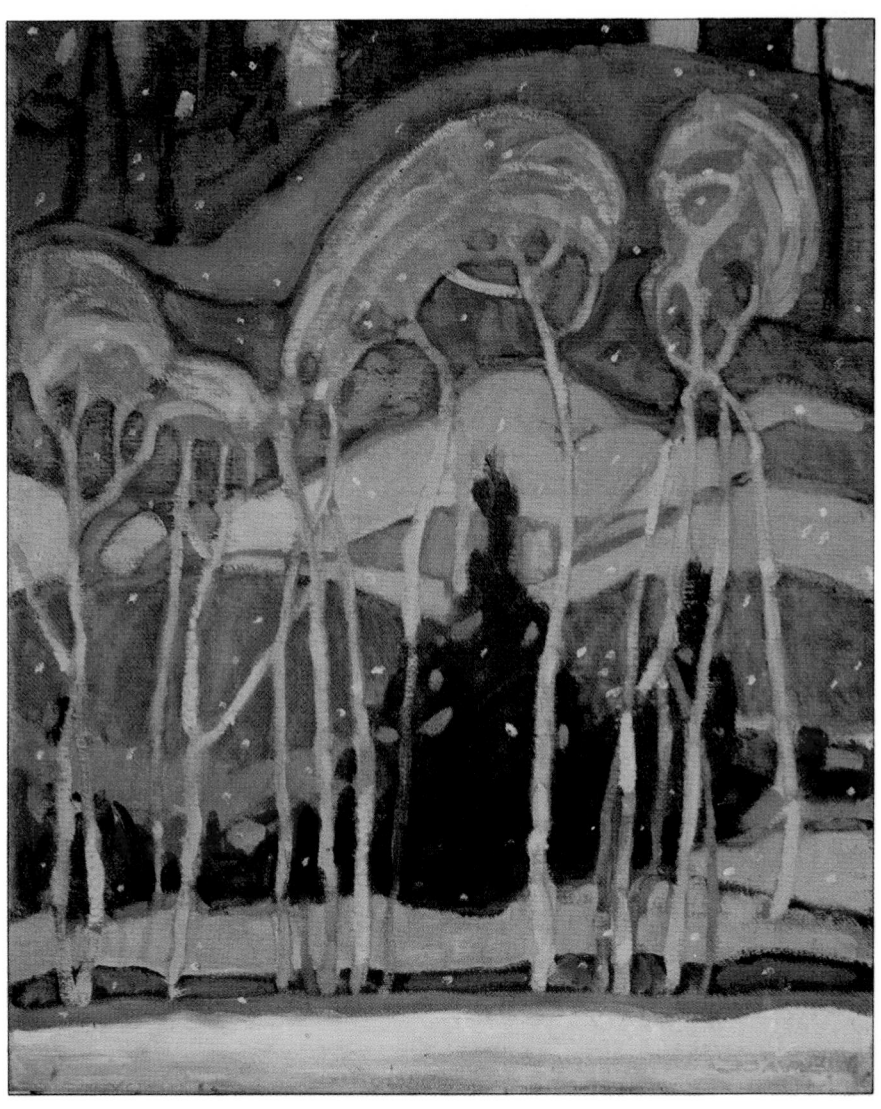

Untitled Winter landscape (Wonish 1920's)

continue for the next decade or so. A.Y.Jackson showed a continued interest in the school and what Anne Savage was doing. In his book, *A Painter's Country*, he quotes from a letter he wrote J.E.H.MacDonald from Baie St. Paul, January, 1924: "There is no great stir in Montreal art circles. Anne Savage is getting wonderful results teaching art at the Baron Byng High School from youngsters, mostly Jewish; this is about the most interesting development in Montreal."

These were the years when Jackson wrote his friends bemoaning the snobbishness of Montreal art dealers who were buying Dutch copies while New York was picking up French Impressionists. He was happier with the colleagues in Toronto who had found a fresh approach, and a city that had a more open attitude to art developments. The stir in Montreal art circles would come later, and it would be of French origin.

Baron Byng, meanwhile, became the springboard for a large number of artists working today. Among them are Rita Briansky, David Silverberg, William Allister, Maurie Rohrlich, Seymour Segal, Moe Reinblatt, Sylvia Lefkowitz, Frances Karanofsky, Tobie Steinhouse and Leah Sherman. Even those who didn't "take art" will tell you what an effect the art room had on their homes, their ideas of decoration, their way of dressing. The only trouble is that the years have polished the memory, and the descriptions are almost too flattering. Annie Hirsh, for instance, a pretty, dark-haired matron living in St. Laurent, says she lives differently because of Anne Savage. She remembers her as "a burst of light and vision" to the average student. Alfred Pinsky gives a more objective opinion. He says that

in his day "art was for girls." The boys did manual training. When Pinsky insisted on painting and drawing during these periods, he was allowed to go to the art room where he and one or two other boys caused a sensation in the all-girl class.

He says Anne was an innovator in art education in this country, in a class with the great European teacher Frank Cizek, or Marian Richardson and R.R. Tomlinson of the UK. She was of the "enlightened English explorer type," he feels, and got away with it, perhaps in some instances, just because she was a woman. He adds: "The Protestant Schoolboard threw all the crazy people into Baron Byng. . . Herbert, Savage. Maybe the Jewish community helped. Lismer [he was to succeed Anne Savage at the Montreal Gallery children's classes in 1942] used to say that without the Jewish community his classes would never have gone anywhere." Yet the effects were pervasive. "I am starting the graduate program in art at Sir George Williams today," Pinsky concluded in an interview in the early seventies, "directly because of Anne Savage."

She was, in fact, teaching art at a crucial time in the development of art education on both sides of the Atlantic. She was aware of the movements to the south in the United States where "progressive education," which had been interrupted by the First World War, entered a vigorous decade in the twenties and came to maturity in the thirties. More and more educational leaders were coming to believe that development of children's natural interests and creative abilities in all fields would give a better curriculum than the old, adult-designed one. As for art, it was pushed as the

most creative of all possible activities for children in school.

There were examples of men and women all over the United States who held to this belief. Anne's bookshelves were an indication of her interest and awareness of the work of teachers such as Margaret Mathias at Cleveland Heights public schools, Patty Smith Hill, Hughes Mearns, Frederick G. Bonser, Belle Boas, the Francis W. Parker school, C. Valentine Kirby in Pennsylvania, William G. Whitford at Chicago University, Leon L. Winslow in Baltimore, Victor D'Amico, Ralph Pearson, Robert Henri and Kimon Nikolaides. All these teachers were freeing students from old methods of "learning art" so that when the Bauhaus exhibit opened at the Museum of Modern Art in New York in 1939 there was an audience ready for its message. This called for a wide use of all kinds of materials, including old crafts, and followed Walter Gropius' idea of "unity of art," wherein one art form influences another. Industrial design leapt forward as a result. John Dewey, the philosopher, championed the quality of awareness in his book *Art as Experience* (1934) and deplored the isolation of art objects in a museum. By the time the art critic Herbert Read came to write *Education through Art* in 1943, there were many who accepted his introductory sentence which he borrowed from George Bernard Shaw: "I am simply calling attention to the fact that fine art is the only teacher except torture."

Anne Savage, along with Arthur Lismer, was recognized as leading the new art teaching in Canada. And yet they both were painters first. She said to Arthur Calvin:

We were really painters more than teachers. It never

entered my head to be a teacher. The wonderful thing was that I bought five years solid training in nothing but art which stimulated the whole of my teaching career. I think that's the whole secret, that you get a good base, then you can work. Many people who train to be teachers try to hitch onto something like art afterwards. It can be done. It takes them longer to do it, that's all.

As a painter she couldn't help influencing the students. The strong rhythms that mark her best painting also emerge in their work.

Leah Sherman recognizes that teaching and painting feed each other. In teaching, she says, one learns the possibilities of the media, as well as the possibilities of the pupils.

"What saved Anne Savage," Mrs. Sherman says, "was her value of the child as a creative person. She never put one down. She always found something to like and encourage in a child's drawing. In all the years I knew her, and she had hundreds, thousands, of students going through her classes, she never lost this attitude. Well, it was part of her. She couldn't help seeing beauty, she couldn't help passing it on. She had these strong perceptions and visual sense and the kids knew it and no matter how she expressed it they knew it was completely genuine with her and she never changed. At Sir George we have been studying what makes a good art teacher. There are no rules. It is not a matter of technique. With Anne Savage it was her set of values which underpinned everything else. The kids felt this. She never deviated from them."

Finally Mrs. Sherman said: "Anne Savage needed to

teach. It was her vehicle," and added that she could have been a minister if she had been a man.

Anne Savage was a Presbyterian who deeply believed in the Christian teachings. She was teaching Jewish children who held to quite another faith. Yet between them they touched the same wellspring. When she died the church was packed to the edges with pupils who loved their God the same way Anne Savage did hers.

She was to teach art at Baron Byng from 1922-1948. After that she supervised art education for the Montreal Protestant School Board for another four years, retiring in 1952.

There is little doubt that the big east end high school was the overriding influence in her life. It was the key to another world, far removed from the conservative Montreal she lived in. It gave her total freedom to express herself through art. For her, it was much more "amusing," as she was fond of quoting the French as saying, than taking a lonely studio and putting up her easel. She had the contact, stimulus and enthusiasm of generations of bright students. All winter she painted alongside them. Come summer she was ready to try out new ideas in her own painting. As an outsider in the Jewish environment of St. Urbain street, she could forget everything but the painting she loved. For this she thanked Baron Byng High School until the end of her life. For her affection the students, on their part, are still thanking her.

Untitled (Eastern Townships, 1930's)

5
Clinging
to
Paint

School will be out in a few minutes
and your sweet self will be walking
home, perhaps over the mountain,
where early winter has covered up
dead summer and spring is already
waiting to shout with life in a few
short months.

AYJ to ADS, 23 November 1933

The twenties were the years when Anne Savage struggled to think of her own painting before all else. At times it must have seemed like a juggling act, with demands from home and from teaching.

While both her sisters married (Elizabeth, or Queenie as she was called, to T.W.L.MacDermot, a professor at McGill, in 1924; and Helen to Brooke Claxton, a Montreal lawyer, in 1925) Anne Savage turned down beaux and suitors. She spent her summers on sketching trips, often north of Montreal or in the Eastern Townships.

She had two pictures accepted for the historic British Empire Exhibition at Wembley in 1925, a harmless sounding show which, along with the first Wembley show held in 1924, was to mark a watershed in Canadian painting. While the Royal Canadian Academy of Art more or less boycotted the Group of Seven, the Canadian painters were widely acclaimed in the United Kingdom and hailed by the London *Morning Post* as "the foundation of what may become one of the greatest schools of landscape painting." After Wembley, Canadian art collectors started to buy the controversial landscapes of their own country. One of Anne Savage's Wembley paintings was the "Ploughed Field," a picture full of colour and movement.

In 1928 Anne Savage went out to the Skeena River in BC on a trip organized by the National Gallery and the anthropologist Marius Barbeau. The bases of the Indian totem poles in that beautiful district were rotting away and Barbeau wanted to record the totems before it was too late. Anne Savage was to make drawings of the Indian

Ploughed Field (1924)

workmanship, while Florence Wyle was commissioned to sculpture them. Barbeau's work marked the beginning of interest in west coast Indian art.

It was a difficult trip to make in those days. From the train they rode in by horseback to the primitive lodge at Hazelton, close to the dangerous, cold Skeena River. In a way, the two women experienced some of the thrill of adventure that was always part of the Group of Seven's expeditions. It made a great impression on Anne Savage and her excitement and intensity show up in a set of sketches she brought back. They are a collection of small pine boards, 10″ x 12″, and show the dusky totems standing against the heavy green-black of the BC bush, with turquoise peaks behind. The mountains and pines, although done on a small scale, are monumental in their effect. Anne Savage valued the paintings and kept them together as a complete collection all her life, something she rarely did, being, as she once said, "very loose about art." She would spontaneously give sketches and paintings to friends and family as wedding gifts and other presents and then in an equally spontaneous way ask for them back to go into an exhibition. They were her children and she had trouble parting with them permanently. She also refused to sell, many times, for reasons which she wouldn't explain. All in all, it makes cataloguing her work difficult.

At least two of the Skeena sketches were made into canvases. "The Owl Totem" was shown at the Art Association exhibit in October, 1928, the *Montreal Gazette* noting "a strong decorative sense." "Hills on the Skeena" went to both the Royal Academy show and the National

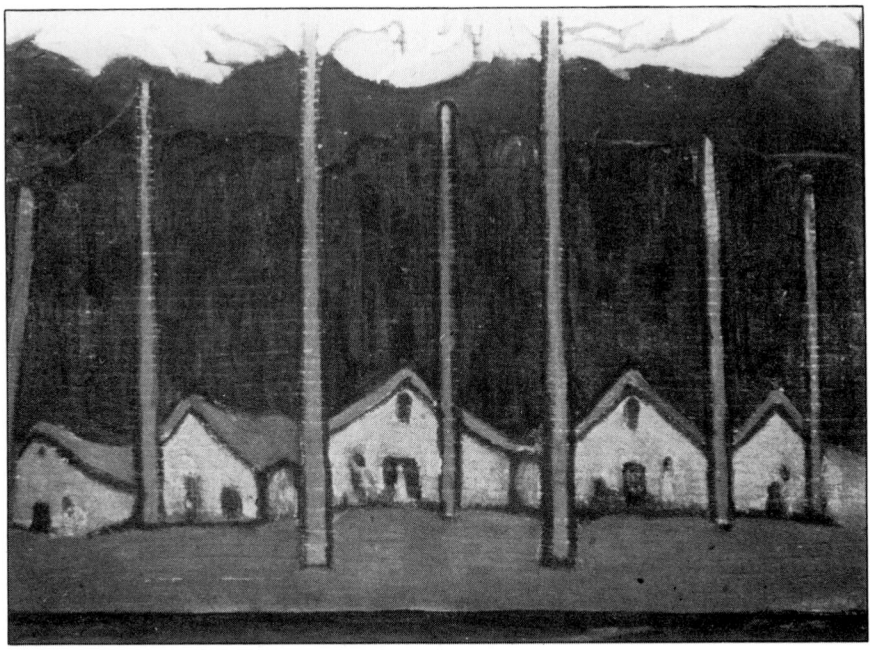

Untitled oil sketch (Skeena, B.C., 1928)

Gallery in 1929. Barbeau used "Hills on the Skeena" along with work by Emily Carr, Langdon Kijn, Jackson and Holgate, to illustrate his book *The Downfall of Temlahan*.

The summer Anne Savage and Florence Wyle went up the Skeena was the year Jackson and Dr. Frederick Banting (of insulin fame) took off for the Arctic. When they set out they promised to compare notes when they got back, the men warning the girls that they would get nothing but mosquitoes up the Skeena, which turned out to be at least partly true. They all met in Montreal afterwards and had a party, putting up their sketches for the rest of the group to see.

"She was crazy to paint," remembers Nora Collyer. "She used to come out to visit me at Foster, in the Eastern Townships, and stay until the last minute before school started. I remember getting her on the train early Monday morning so she wouldn't miss a day in the country. But Highland Avenue was her home. She would never have taken 'a pad' in the east end, she was not Bohemian in that way at all."

It is Nora Collyer who, among Anne's contemporaries, best remembers her high spirits and sense of fun. She tried to give examples but they are difficult qualities to bring back without comparison to schoolgirl pranks. She seems to have blossomed when she got off on a trip. She had a sense of the ridiculous, especially about herself. Miss Collyer remembers her flying off a bicycle on a winding lane, on a visit to England. She landed unhurt at the feet of a driver who was bringing his horse and cart out of a sidestreet. On another occasion Anne was asked to

"chaperone" her niece and nephew on their first trip to Europe. Arthur and Elizabeth, the children of one of her older half-sisters, Winifred Grier, were about the same age as Anne. On board ship she had such a good time dancing that a stiff dowager asked her to refrain from such rowdiness. Anne drew herself up to her full height and said: "May I introduce my nephew?"

After she started teaching, Anne Savage had less and less time to get down to the Beaver Hall studio, making it only on the occasional Saturday. She sent a painting in 1927 to the Musée du Jeu de Paume in Paris. She did the occasional portrait, one of them a sympathetic profile of her teacher, William Brymner, owned by the Art Gallery of Hamilton, and another small oil painting, "John," of her first nephew, which was shown at the Art Association Spring Exhibition in 1929. Her sketches from this early period have a direct, uncluttered, piquant style which she would lose later and only recapture in the flower studies of her last years.

Her main interest became landscape, probably as a direct result of Jackson's cry to all and sundry for "more and better canvases" to show what Canada looked like. She sometimes returned to Métis, where she had gone as a child. She sketched pink rocks, upturned boats, shells at low tide. She went through a period when she dragged nets across her pictures, sometimes actually attaching paper and string to a painting as it was underway to get, she said, a feeling of mystery, a departure from the literal. In these experiments she was working more abstractly than Jackson, who painted nature as a designer composes a set and worked out a muscular Impressionism of his

Untitled (Métis, 1940's)

own to show the character of Canada as he felt it. When he "dug into the raw sienna" it was a physical thing. For him it was the only way to paint. He wrote her on October 4, 1931, after a strenuous camping trip:

Anyway I'm as husky as a piano mover and if I can sublimate my physical energies and turn them into art it should not be any weakly stuff.

She was never able to be so frank.

Although Anne Savage always impressed people as a bonny, vivacious woman, in many ways she was not as strong as she looked. It seems she developed thyroid trouble when she was about ten or twelve. The doctor didn't operate and although the condition was brought more or less under control it prevented her from participating in active sports. She had palpitations when in her teens. When we were children we were told Aunt Annie had a bad heart. She was very energetic when it came to painting or packing material into her car for school. But she didn't take part in any of the baseball or Run Sheep Run games we had in the country and although she swam it was always rather sedately. She was shy, certainly noncompetitive, and so retiring emotionally that it affected her physically. She became "the audience" for most of the activities around her and may have put off marriage partly for this reason.

It is curious to examine her paintings alongside those of the senior and more forceful Jackson. They are almost the feminine counterpart to his work. The effect was surely

not deliberate and yet the work done in her prime years, much of it in country he also covered, shows a more lyrical, intimate aspect of the hills and valleys that he turns into stern backdrops. The brooding history and romance of the kelp-strewn St. Lawrence shore, for instance, had the same fascination for both of them, perhaps for any artist captivated by the patterns made by the old farms as they fold back from the coast. His paintings are monumental, often grey and lowering, partly because he worked in the spring before the sun had taken away the last snowbanks. He used the Impressionists' technique to capture the pearly white drifts. She got there in the summer when school was out and her Métis pictures are emerald, sparkling and sunlit. She did closeups where Jackson did panoramas. Her "Strawberry Pickers, Cap à l'Aigle," for instance, is a trio of little girls in sunbonnets, almost life-size. Jackson's concession to human life, in a very settled part of Canada, was often one small sleigh in a vast snowed-in valley.

Jackson's paintings of Banff and the foothills around Calgary have the enormous sweep and power that were his trademark. Hers chime in with more radiant colours, sometimes more detail in the foreground and more unevenness of conception. In moments of inspiration the pictures have a flair that is quite her own, a reflection of no one else's style, consciously or unconsciously. She would recognize this quality, telling us sometimes, "I think I've a good 'note' there." But she was too modest, or unsure, to pursue it relentlessly and perhaps happier in the supportive, companionable role of teacher.

of a Canadian Painter

The Red House, Dorval (1928)

Anne Savage: Story

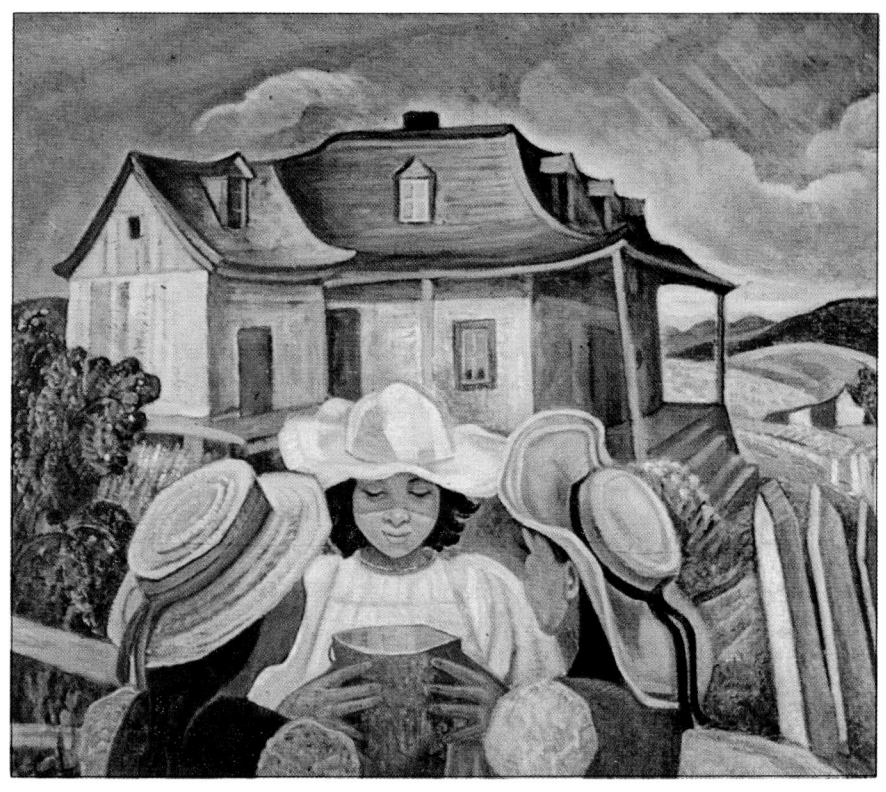

Cap à l'Aigle, Strawberry Pickers (1930's)

She told Arthur Calvin how her painting made it possible for her to teach:

I used to go back for summer holidays to Métis and stay with my sister, Mrs. Earl Birks. I usually went there in June when the greens were fresh and the white daisies just starting to come out. I would take the car and start right after breakfast, on the search. The land rolls away in great sweeping folds and the forms run in long laps right up from the sea, field after field. It is like a patchwork quilt. But the difficulty, the terribly hard thing to do, is make up your mind what to paint. I understood so well the problem facing the students and I tried to practice what I preached. You have to be very firm with yourself and try to keep your mind on the type of motif that you want to do or you will be led astray. You'll wind up confused and frustrated and say you'll never paint again, and the time has gone.

I couldn't have taught those students even to approach the discipline needed to paint without having really tried and done it myself. Then I would come back in the afternoon and repeat the program. The afternoon light was so much softer and warmer than the morning and the shadows were longer and drawn out I think I only did about six big canvases of Métis but I kept a reference library of twenty good sketches to make into paintings.

She kept the sketches, but her energies went into her job and her job was teaching. It was also her audience. Over the years they drew even closer. Anne Savage probably struck the balance she wanted.

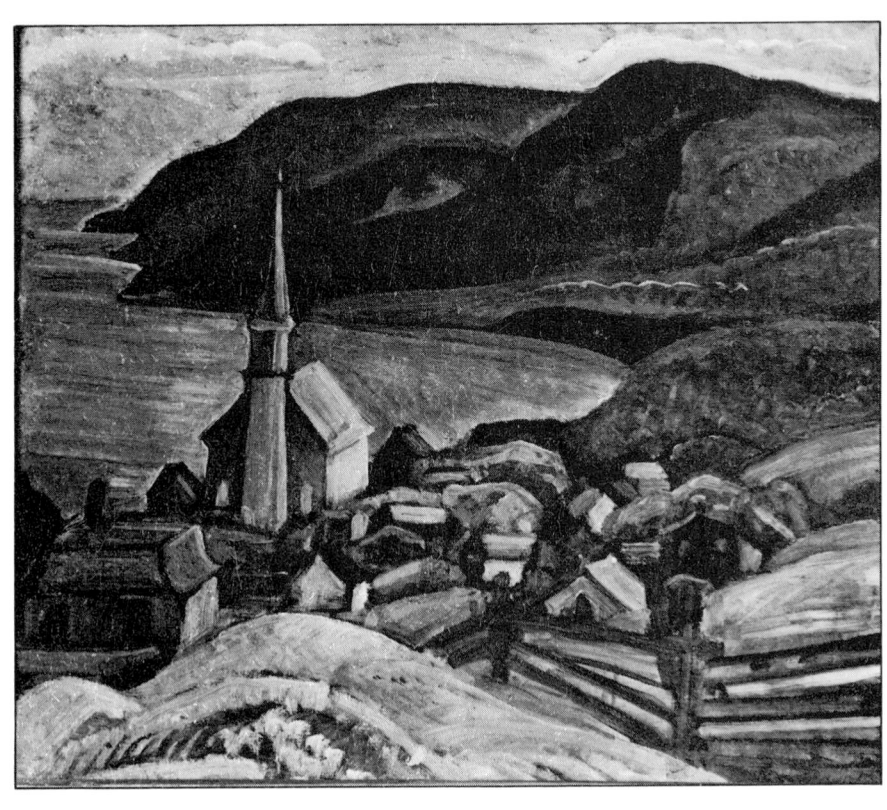

Untitled (Lower St. Lawrence, 1930's)

6

Painters' Friendship

That is the way to paint.
Just tear into it.

AYJ to ADS, 27 January 1933

By 1931 Anne Savage had started to keep A.Y.'s letters. January 2, 1931 is the date of the first letter found in the basket in the cellar. March 8, 1964 is the last. There are two periods, from 1931-1933 and 1939-1941, when they seem to be writing about once a week and some 100 letters from Jackson remain from each period. Then there is a mysterious gap from 1934-1939 during which she kept only two letters from him. During these years, however, the letters that he kept from her show no break in their correspondence. She may have had some reason to destroy his letters or they may simply have been lost in one of the periodic efforts she, and later her sisters, made to "tidy up the cellar." During the last twenty years of their lives, the correspondence slows but never stops completely.

In recent years, A.Y. Jackson's paintings and his colourful lifestyle have been widely written about. He became a legend in his own time, living to the age of 91. And yet, another side of the painter emerges in these private letters. It is that of a warm-hearted man, capable of great loyalties, a man with very tough convictions but very little vanity. He is a steady flame in the lives of his friends. The letters themselves are a surprise in the clarity and pithiness of their expression. Although he considered himself a man of action rather than words, his spare and precise accounts of what he's doing, his next trip, friends who have dropped in, canvases that have to be sent, hung, and judged bring to life a whole era in Canadian art. It was the heyday and fading out of the great Group of Seven and its successor, the Canadian Group of Painters, and the beginning of abstract art in this country.

Anne Savage was only one on Jackson's list of correspondents. Their letters may be unique for the unhappy reason that other members of their painting group – in particular Prudence Heward and Sarah Robertson – were to die comparatively young, in 1947 and 1948 respectively. Anne Savage and A.Y. Jackson had many long years to look back on their friendship.

In 1931 they were talking business and the question was Christmas cards. On January 30 he wrote her:

Would you and Nora Collyer like to send me each a couple of designs to show Rous and Mann ... flat colours or wash. Lively in colour and Canadian motifs I expect your little troubles at school were not really very funny for you ... If you get in any more difficulties just send for 457316 60th B [Jackson's army serial number] and to him anything you do will be right.

It was often Jackson who organized these artistic schemes such as the Christmas card game. He went to endless trouble:

I wrote Holgate four times (July 23, 1931) and he never even answered so I told Coutts to send a cheque for $50.00 for two designs. I asked Robinson to send a couple of his old sketches up. He replied to the effect that he couldn't be bothered.

There is plenty of comment on other artists' work, but very little gossip, which may help to explain the five-year gap in Jackson's letters. This was the period when two of his

friends, the Fred Bantings and the Lawren Harris', were going through divorces, and his niece, Naomi Jackson Groves, thinks A.Y. might have asked Anne Savage to destroy his letters at that time. It would also have been in character for her to edit them out of the collection at a later date, perhaps the same time she decided to keep the others for posterity.

Jackson is perceptive and compassionate about his friends, as in this pair of letters:

November 25, 1932

Poor (J.E.H.) MacDonald has had another break-down. He has been trying to run the school as he had no other income, it is a shame that he could not have devoted himself to painting, he was just as much a genius as Thomson but he had a whole collection of relatives living on him and he has never been free from anxiety.

And four days later:

Well, we buried poor old Jim MacDonald this afternoon. He was a strange complex character but a great figure. It will take time for people to realize it. Too much of his work was done just to earn his daily bread and he put beauty into things that were not worthy of it.

Anne Savage's letters to Jackson survive from this period in about the same numbers as throughout the rest of their correspondence, that is two to six a year. The rest were lost.

In reply to one from her, written at this early period, he says:

I don't think Lawren is cruel, he merely paints a world that is not related to humanity, a world without passion or emotion. The peculiar thing is how people react to it. It is almost popular here. People who otherwise have no taste at all will get ecstatic over it. The other day a chap in Ottawa who has a tremendous admiration for [Wyley] Grier's banal portraits, almost went off his nut over Lawren's pictures. Lismer's work is generally detested.

A.Y. could be tactful and helpful in criticism:

Yes, I think Sarah [Robertson] like a lot of other artists in trying to escape literalness runs into formulas at times. It's hard to escape it. You must stylize to some extent. We all do. It's the Horne Russels who can't.

About Anne Savage's work he was generous but did not withhold criticism:

'The Plough' looks fine . . . if the orange hill had been a little more violet grey I think it would go better.

In fact they all jumped in to help:

Prue [Heward] is still here and seems to be having a real good time. She will tell you about 'The Plough'. She thinks it is a fine design but wants to change the position of some of the colors.

And also, more severely:

I did not feel that your canvas in the Spring Show quite came off, but you have a nice one of a lake done a few years back that would do fine.

Jackson was living in the now famous Studio Building on Severn Street in Toronto, built before the Group of Seven had even been organized by the far-seeing Dr. James MacCallum, with help from Lawren Harris. A homey picture emerges in his letters to Anne Savage from this setting:

I was going to write you a big long letter but Bill Beatty, the bête noire of Sunday mornings, came up from the studio downstairs and sat and sat and now I have to rush out for lunch . . .

The end of my studio is covered right up to the ceiling with designs for stained glass windows and I am working in Thomson's shack in the rear but I live here at nights.

During the school year she wrote him about her days at Baron Byng. The school, for one thing, was making a mark of its own in outside exhibits. Norah McCullough, at that time assistant to Arthur Lismer at the Art Gallery of Toronto, recalls its work going on exhibitions Lismer organized in Nice, as well as Capetown, South Africa. The work of Baron Byng students was used as the basis of layouts for Christmas cards, as well as for rug designs. Jackson thought about the school and the students on his

travels, writing Anne Savage from Willisville, Ontario, one fall:

I found some pitcher plants which I will try to send for your Baron Byng kids to draw. I found a little lake up in the hills and it was just surrounded by these pitchers.

He even got involved in her plans to decorate the school with murals. This sequence of letters shows the care and thoroughness he put into a project when it interested him.

October 22, 1931

. . . I saw Thoreau MacDonald [son of the painter J.E.H. MacDonald, and an artist and designer in his own right] a few minutes ago and asked him about a panel. He says they are hard up and would do it for whatever you could collect. Something with birds or animals. Let me know.

December 3, 1931

. . . Thoreau showed me a pencil sketch for the basement decoration. It looks quite good, a flight of wild geese [sketch in the letter] with a landscape below and an azure blue graduated sky, 40 inches wide by 50 high. Better try out that size, he would make it a little deeper if you wish.

December 9, 1931

. . . The wild geese are flapping their wings. I went down to see how they are getting along yesterday. Thoreau is doing it on canvas and will send it rolled up.

Boys painting the Dragon mural at Baron Byng

You might mount it on beaver board or on a stretcher. The space below might have a verse or quotation on wild geese, made with the frame. There are a lot of poems on the Canada Goose. There is one my brother knows and is very fond of "From the far north they wing their way, etc."

January 12, 1932

 . . . Went in to have a look at Thoreau's Wild Geese and made a few suggestions. They should look swell on the wall. The nearest goose is exactly life size. It looks kind of heroic. It would be great to extend the idea to moose, caribou, mountain goat, eagles, blue heron, timber wolves, and so on.

January 24, 1932

 . . . So the Wild gooses are going to look well. Thoreau was very pleased. He said the canvas was stiff enough. He did not think it would need a stretcher. Just lay it against the wall and hold it with the frame which should be like a lath.

In the wake of the Wild Geese (which are still hanging in the school's front stairway) came some of his own work. The youngsters of Baron Byng were to run up and down the stairways past some of the most exciting painting being done in Canada. It happened when he was clearing out his studio in Toronto. In a letter of October 26, 1932, he wrote:

Dear Anne,

One thing I am doing is to send you a package of sketches for the Baron Byng school, if they want them. I picked out ones from all over Canada so they should be interesting from a geographical standpoint. Do as you please with them; they might have plain black strip frames around them later

And in reply to her thanks he wrote — ending with a characteristic tip of his hat to a new order of things:

I am glad you liked the sketches and if the Baron Byng school accepts them I will feel highly honored. Your school is a symbol of a finer educational system which is going to come. The present capitalistic era is putting itself out of business and we will soon have a swell new world.

There is not a great deal of introspection on Jackson's part. What there is in a personal way usually comes on his birthday. She, for her part, seems to have had occasional outbursts which we can only judge from his replies (October 11, 1931.)

It was a nice little letter you wrote, Anne, in rebellion against the inevitable — resignation and humility and imperturbability or complete detachment or indifference. I don't think the bon dieu *worries much about our attitudes, and I don't think he carelessly drowns a couple of million poor Chinese or shoves another poor soul off a steel girder. Perhaps he is sorry but he can't do anything to interfere with his natural laws. I enclose a poem of*

Masefield's. It comes at the end of the play 'Pompey the Great'.

He attached this page to his letter:

And all their passionate hearts are dust
And dust the great idea that burned
In various flames of love and lust
Till the world's brain was turned.

God moving darkly in men's brains
Using their passions as his tool
Brings freedom with a tyrant's chains
And wisdom with the fool.

Blindly and bloodily we drift
Our interests clog our hearts with dreams
God make my brooding mind a rift
Through which a meaning gleams

 Masefield

Their friendship deepened, in spite of indications that she had discouraged him some years before. In March, 1931, Jackson wrote to her from Ste. Irenée, Quebec, assuming a role he liked to play, that of tough outdoorsman:

But I have to remember I'm one of these rough birds from the big open spaces and me and Fred Banting we just say 'hell' when the north wind blows and then take a chew of chocolate and squeeze out some more frozen

paint and make another buckeye. It's 10.10 p.m. so good night, Anne Savage.

But behind the swagger was a more serious note. In October, 1932, Jackson was in Cobalt, Ontario, where he wrote to her from the Fraser Hotel. He was puzzled over her reluctance to jump into life. He was now fifty, she was thirty-six. Here is the complete letter:

Fraser Hotel
Cobalt, Ont.
October 3, 1932

Dear Anne,
Your letter arrived just a few hours before I left Toronto and the little bird was right too. This is my birthday and you are probably the only person who thought of it. Apart from your good wishes it has not been a very thrilling one. Dr. Banting and I both picked up little colds and it rained most of the day. I painted some shacks under a sombre sky. It's a higgledy piggledy little town, slowly disintegrating, not a mine working. The great days when Cobalt was known as one of the great mining centres of the world are gone for good. Most of the mines are worked out and the others waiting until silver goes up enough in value to pay to take it out. The town swarms with children, the men have gone to other camps but left their families here. The tin and tarpaper and frame shacks are a little reminiscent of Hull. The people are very friendly. Mrs. Fraser at the hotel here is a Basque lady who married a Canadian soldier. She is an

exile, like most French people who migrate, and she is making the best of a sad mistake.

The autumn colour is coming along at last but it has not much to work on . . . bush and second growth on the hills out of which stick up the gaunt mine shafts. It would be an exciting place in winter or early spring. Some day a fire will clean it up and the cheerful citizens will have to move. They took out two hundred and fifty million dollars worth of silver but little of it stayed with the workers. Recently an effort was made to save the old house Henry Drummond wrote many of his poems in and where he died but the few hundred dollars could not be raised and it was torn down.

"Seven wealthy towns claimed Homer dead
Through which the living Homer begged his bread."

But we have not even got to that stage yet. You will be seeing Arthur Lismer and hearing all about his voyage to Europe. It is well we have some people of vision. There should be one to every hundred stoopids. It is very thoughtful of you to send the electric pad to keep a body young and fit. I will use it and bless the sweet and gentle donor.

You have been a dear and constant friend. Even when I have been careless and forgetful, your cheerful little letters have come along. Until now I would feel lost without them. Perhaps you remember years ago when I was rather obstreperous. You wrote just a little severely to make me understand that our acquaintance was nothing more than good friendship and that friendship I have been very proud of ever since. But this birthday rather bewilders me. I'm a complex individual. I have many friends and

*contacts; for some reason I'm popular socially without
wanting to be so very much and here I am getting on in
years. Next door to me the horrible example of
Williamson, soured, lonely and helpless. I am pretty
happy. Eugene O'Neill says happiness is only a
by-product. That people who search for it never find it.*

*I don't know what little Annie Savage will make of all
this and I wonder if she just wants to go on being good
friends until the end of the chapter and I wonder if she
realizes how pretty she looked in her green costume or if
she knows how many girls come to tea in my studio and
tell me I'm wonderful. But she has so much to do, her life
is too full of good deeds to spend time in mere fancies.*
With all good wishes,
as ever,
Alex.

Jackson is playing to the gallery in the closing lines and a
touch of bitterness creeps in. And yet the reticence wasn't
all on Anne Savage's side. After an apparently more
encouraging letter from her, which hasn't survived, he
concluded a letter to her of October 26, 1932:

*Your dear little letter came yesterday. One of these days
I will become more articulate. I'm about two-thirds
Scotch so please allow for that dear Anne, with very best
wishes, as ever, Alex.*

They seem both, on the whole, to have been much happier
discussing painting.

On February 25, 1932, Jackson wrote from the Studio Building:

Your devastating criticism of my works of art has just left me flat and I suppose I will have to start all over again to do some good painting. Well we will do our best to win your good opinion and then of course beneath all this severity there is a kind little heart ready to overlook a lot of shortcomings. Lismer says a lot of the things at Ottawa were poorly hung and badly lit. Anyway, we won't excuse ourselves.

And two months later he was back at Les Eboulements, Quebec, half way through his stack of sketch-boards.

Well, here's me going to make some wild and woolly ones. I gave Randolf twenty-five to take back and now I'm going to start all over again and each one I'm going to say: "Now Anne will that make you sit up?"

When her letter came ten days later, he nodded to her suggestions – half joking, half serious:

Your letter arrived at ten last night so I am going out to paint a sleighless landscape, anything else you would like left out or put in, just wire me.

But Jackson was making his living by painting and had other people to please. He was to write her again, just a year later, from St. Urbain, Quebec:

At twenty-five sketches, the half-way mark, I will let up a little. I am putting little red sleighs in most of them as a concession to the public demand. I really should put dog sleighs in as that is the chief means of locomotion here

But the real artist in him knew what he was about:

Glad you like my stuff in the Spring Show, the forlorn barn is probably the best of the three. It is a sphere surmounted by a cube, that is the problem. It will not be appreciated by Mr. Poynter Bell or other famous critics.

Jackson's letters give the feeling that he is often working for an absent audience and that Anne is there beside him. He had many friends to paint for but there is evidence that he seemed to want her criticism, writing:

You can make all the cheeky remarks you like about my sketches, it's good for me and I don't want to be put on a little pedestal. I've seen people put on those things and then left there and forgotten.

And yet he put *her* on a pedestal though it was not the right approach for either of them. After a trip to Montreal in 1931, he wrote:

It was a happy little visit to Baron Byng and the car ride and the walk was just kind of thrilling. I mentally put you in that shrine we passed and I'm sure there was an aura round your head.

And, in the following year:

You are one of the few beings I know whose lives are so beautiful and serene that they rise above all the tumult and meanness of life.

Early in 1933 he wrote:

I am trying to get some work done. That one of the terraced hills back of the little barns is a problem. It is so hard to get the snow low enough in tone and yet keep it pure in colour.

In the same letter came probably the best advice he ever gave her:

Well here's to 'The Plough'. It sounds as though you had made it live. That is the way to paint, just tear into it.

She replied:

I'm glad you thought 'The Plough' was better. I'm at the stage of not knowing how to push a thing through without making it look mulled over and rubbery, just as you were saying about the far snowbanks.

While they seem to be writing each other about once a week in these early thirties, a study of the correspondence is unsatisfactory because of the scarcity of letters that remain from Anne Savage. The Calvin interview helps with the gaps. She was happily involved in a painters' world. In

1929 she had a visitor from the west coast, Emily Carr; it was Miss Carr's first trip east. Lawren Harris, remembering Anne's trip to the Skeena River, wrote and asked her to look up Emily Carr. Anne Savage says she went down to the Windsor Hotel, knowing nothing about Emily Carr, and found:

a little woman with a little dog. She was a small woman with dark beetling eyes and a very sharp nose and a very intent look. She just looked at me almost like a bird. She turned out to be simply enchanting. She was at this peak of enthusiasm of wanting to go back. She was going back to do what she had been inspired to do by Harris and A.Y.Jackson. I knew I had met somebody who was just on the verge of some kind of expansion. We talked until nearly two in the morning.

Anne read all Emily Carr's books and envied her ability to write. She said to Calvin:

She had the ability to just put down exactly what she meant, like Vincent Van Gogh. But she could do it in two ways, with paint and words.

Emily Carr went up to Highland Avenue for Sunday lunch during her visit to the East.

These were the days when Canadians all over the country were waking to the excitement of building their own nation. Slowly but surely ties with the Empire were being modified or severed. If painters like Jackson and

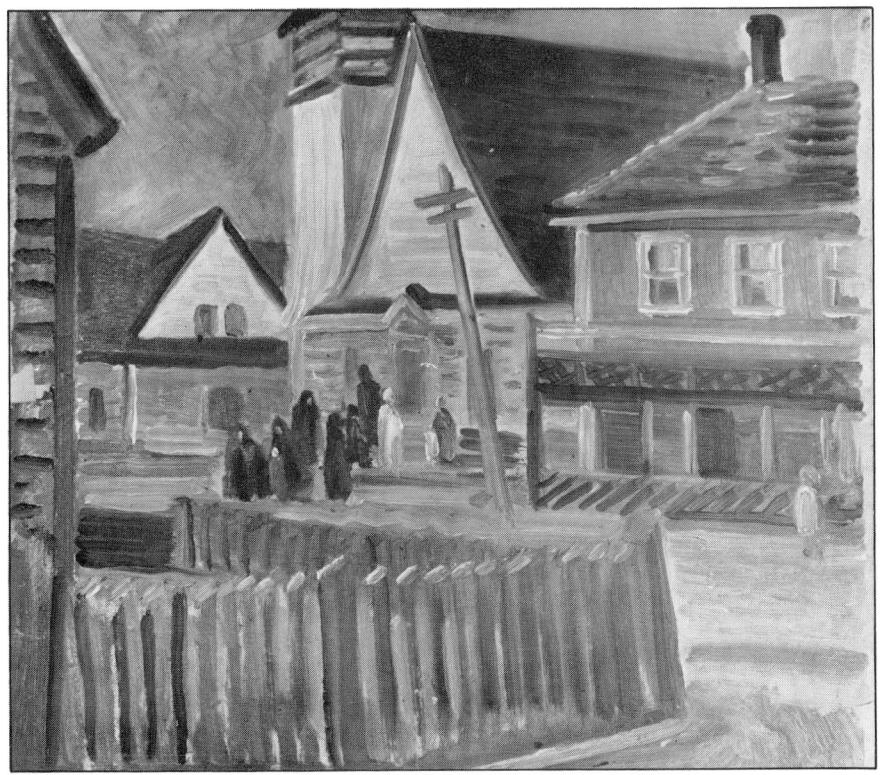

Untitled (Lower St. Lawrence, 1940's)

Emily Carr were fighting to find Canada visually, there were knots of poets, writers, economists, lawyers, politicians and businessmen all over Canada doing the same thing in their own fields. Many of them sent articles to the *Canadian Forum*, a magazine which had pioneered recognition of the Group of Seven in the twenties and whose left wing slant A.Y. and most of his artist friends found congenial. He often sent Anne Savage clippings from the *Forum* and other periodicals. She got a new perspective from reading Frank Underhill, J.W.Woodsworth, E.K. Brown, Frank Scott, Dorothy Livesay, A.J.M. Smith, Margaret Fairley, Norman MacKenzie, Robert Ayre, Donald Cameron and a score of others, all working to build a new society in a new Canada.

They were building in spite of Depression bleakness. Jackson wrote, on October 4, 1931:

So it's school again. From what all our financial experts are saying, one will be lucky to have a job this winter.

And still the painters kept at it. In 1930, besides exhibiting in Montreal and Ottawa, Anne Savage was to send a canvas called "Laurentian Village" to a show in Washington arranged by the group of Contemporary Canadian Artists in conjunction with the American Federation of Artists. In the following year she sent "Shacks at Gaspé" to the Baltimore Pan-American Exchange of Contemporary Paintings. This is a strong moody painting in blue and green with a heavy atmosphere of salt and fog. It is owned by Mrs. Brooke Claxton.

This was a period in Canada when there were not enough galleries to enable an artist to exhibit on his own. By forming groups, everyone had a better chance of being shown. This practice eventually tied up the galleries and for this and other reasons groups were eventually disbanded. In 1933, however, they were still in vogue and the remaining members of the Group of Seven, the Beaver Hall Hill group and other painters across Canada got together to form the Canadian Group of Painters, the last big nationally organized group of this kind. Once again it was Jackson who was behind the new venture. Anne Savage was only one of the Montreal painters involved. Their letters, however, give a special glimpse into the efforts of organization. A lot of work and courage shows up in the following excerpts, which are chiefly concerned with getting the painter Randolph Hewton into the fold:

Studio Building,
January 5, 1933

Dear Anne,
It was such a happy little visit I had in Montreal and such a rush after I got back, meeting of the group, the old originals, the MacDonald Memorial Exhibition and a lot of other things.
I brought up the question of Randolph right away and of course they were all of one mind and so I have written him. I do not think there is any doubt of it going through now. We are writing a kind of manifesto of our aims and ideals.

January 15, 1933
...The Canadian Group is slowly developing from
Vancouver.... Scott, Weston and MacDonald have
joined us. No word from Emily Carr yet but she will. No
word from Randolph. Is he hesitating? He is likely to be
made an academician but will not be if he joins the
Canadian Group of Painters.

Jackson is touching on a sensitive spot here. He himself left
the Royal Academy shortly after this, to emphasize what he
considered the more progressive aims of the Canadian
Group. It may help explain Hewton's hesitation. On
January 2, A.Y. was to write Anne Savage again:

... No word from Randolph yet and as everyone else
has enthusiastically accepted the invitations to join the
CGP we want to announce it. Stir him up.

January 31, 1933
... The Canadian Group of Painters will be sprung on
the public next week, so stand by, comrade. Our first
show will be in November at the Gallery here. Each
member should contribute four canvases and be the
boldest and most exuberant thing they ever did.
Randolph signed on the dotted line. I had told him
there was no hurry and he took it rather literally. I
suppose Edwin [Holgate] is still away.

The preliminaries over, the new group was launched.
Toronto was given the main credits, but Montreal at least
got a nod. A.Y. wrote on February 20:

On Friday was the first meeting of the CGP. It went off very happily, no pomposity or solemnity, but we put everything through.

Lawren Harris, President; AYJ, Vice-President; Prudence Heward, 2nd Vice-President; and Fred Housser, Secretary. Until it is established it will be advisable to hold our official meetings here. Later it may be run from Montreal or Vancouver. We don't care as long as it moves. It will be announced in tomorrow's papers and our old academic friends will sit up all right. The OSA will feel it first as their show opens in two weeks and most of us are not sending.

After the pressures of organization let up, he left town for a favorite haunt down the St. Lawrence. Engrossed again in his painting, he wrote a jaunty note to his "Dear Anne":

. . . Just escaped disaster. I had a tube of Rubens French Ultramarine, full studio size. But first I was using up some half empty tubes and just by chance in a hurry I took a squeeze of the full tube and found it had turned to rubber. It would have taken eight days to get more and I would have been tied up nicely. I nearly got caught once on the Georgian Bay late in the season. I had a tube of permanent blue and found it was ivory black, wrongly labelled, a 25 mile row to town, so I had to avoid blue subjects.

Jackson is at his most attractive on these expeditions and his letters are full of warm little incidents:

April 11, 1932
... We went as far as the little house you have the
sketch of, at Les Eboulements, and hung out there all
afternoon. I sketched it again from another angle. The
kids were a glorious lot of little ragamuffins dressed in old
homespuns, bits of fur, old woollen tuques, and they had
a wild time running from Randolph to me and back
again.

And from St. Hilarion, the same spring:

... Mme Duchesne has gone. She had fifteen children
and weighed 280 pounds I went out and made a
sketch of the church while the service was on and the
joyous bells rang out. It is going to take some wingspread
to support her. This evening about half the village casually
dropped in to talk it over. The only thing that is going to
be remembered about her is her weight.

From St. Joachim, in March, 1932, he wrote suggesting she
join him: "You had better come down here for Easter.
Easily reached, 20 miles below Quebec, reduced fares." It
was part of a dream he had of sharing the outdoors and the
joy of painting in it with her. In another letter that year,
talking about his picture in the Montreal Spring Show, he
wrote: "Pine Island is the place I want to take you some
day. Do you like it?"

She didn't take him up on the suggestions but did feel
inspired to send off a succession of books, woven ties,
scarves, knitted socks, sweaters, handkerchiefs, a flash-
light, an electric pad for a bad shoulder, cigarettes, and

chocolates. As the years went on, they were posted to addresses all over Canada.

Jackson once expostulated:

Aren't you feeling kind of guilty after cleaning up Morgans [a Montreal department store]? Here I am trying to keep up the spirit of the hardy pioneers and you send me rugs and sketching stools and chocolates and woollen socks and tonics. The tonic would be responsible for some wonderful sketches if there was anything to sketch. I have walked miles in every direction and it does not do anything. I can probably use the stool as the snow disappears, usually I stand up to paint snow because it gives a better foreground but I wouldn't want to get paint all over that rug.

He once wrote her:

Don't send me any more cigarettes or you will make me an inveterate smoker and later will have to break me of the habit.

Despite the affectionate tone, it is difficult not to conclude that Anne Savage and A.Y. Jackson preferred keeping in touch by mail and were happier caring for each other at a distance.

Fisherman's House, Métis (1950's)

7
The Western Islands

From Hope Island we could see the Westerns beckoning and the little lighthouse on its lovely rock...

AYJ to ADS, 25 August 1933

This brings us to the only period in their lives when these two painters might have considered marriage. It was the summer of 1933, but the warmer feelings had shown up earlier in a very ordinary event. In the spring of that year, A.Y. had his tonsils out. Anne Savage wrote:

Baron Byng High School
May 11, 1933
Dear Alex,
I'm not glad in the least that you have to go through with that business, but I am glad that it is going to be over soon and off your mind. Does the end of next week mean Fri. or Sun. night. Does everyone go to the General in Toronto? Here there are three and it leads to confusion.

And Alex, where are you going to convalesce. You can't go back to the Studio. I remember so well when mine came out. I was seven and when I was going under I can still feel the sensation of being on a runaway horse. And then a delightful diet of ice cream and eggnogs. They take them out under local now and it is better. I'll be glad when it's over and shall pray for sunshine for the next 3 weeks. That will do you more good than anything.

So you are properly out of the Academy — well it is better than being in an organization that doesn't function more efficiently than it has and tries to undermine the structure of real art life. Why can't people be more generous and yet we all have to watch that we don't slide into the same pit ourselves.

Let me know the time and place, there's a dear, and then I'll give you a holiday from letters. The bestest of wishes.

The operation was successful; the patient, feeling a little sorry for himself, made an appealing picture. On June 11, Anne wrote again:

It is a hot, sticky night and the peonies are heavy in the garden. Midsummer will be here before we can turn round and then the precious days will go apace.

Yes, only two weeks and then 'the flood gates are open — away to the sea.' It's the grandest thing I know and it is the privilege of so few, only children and those who don't quite grow up.

Where are you going — to the Georgian Bay — and how are you feeling. Has the trouble in your shoulder cleared up. Take the whole summer off in some balmy quiet place and just float with the current.

The dearest little breeze has just sprung up. The air is full of a strange ecstasy. I think if you were here I might be able to talk to you — but then if you were no doubt I would remain dumb.

So — goodnight to you, Alex, just forgive my nonsense — remember it's nearly 90 in the shade, intoxicating June.
Anne

On June 28, Jackson wrote inviting her to join a camping-sketching party his cousin, Mrs. Ericksen Brown, and her husband were organizing at the Georgian Bay. It meant going out to the Western Islands, which Jackson described as:

a little group of rocks and islands far out on the Georgian Bay, wild, windswept, the home of gulls and a

Untitled sketch (pencil and watercolour)

*few rabbits, one of the islands covered with pine but most
of them bare rocks.... About four miles further out is the
Western light. No one ever seems to go there. It should be
a great place to sketch. Mrs. Brown says if you can
consider it bring Lil too, if that is possible. It's a great
adventure. Do you want to come? No expenses but rail
fare and you will easily make that up with your sketches.
The Browns are old campers and do not take any foolish
risks. Frank Brown is an enthusiastic amateur painter and
I will do everything I can to make you happy. So there
you are dear.*

Perhaps she balked at being asked to bring Lil (the
attractive Montreal portrait painter, Lilias Torrance New-
ton). Her reply was not kept. But on July 5 he wrote,
using a weapon we had always found effective with my
aunt, an appeal for sympathy, to which he added a touch
of bantering blackmail:

*I'm glad I only had one set of tonsils.... I went
shooting down into such a state of depression as I have
never known before. If I had heard a shell coming I
wouldn't even have ducked.*

*I never had much sympathy with depressed people but
now I know how they feel and I know if one can forget all
about one's self it will never happen. That is why you will
never have one Anne. I wrote you at Sixteen Island Lake
extending an invitation from the Browns to the wild
windy Western Islands. If you don't come I'm going to
disobey orders and swim a mile a day and go tearing all
over the 39 shoals and islands.*

She said yes.

He sent another note on July 12:

Well there is going to be no depression on the Western Islands and you can paint and swim and sing and shout to your heart's content, Anne. You should get something to paint up, with any kind of luck. There will be nothing to stop you from work except eating. Wear any old togs out there. At Go Home it is the regular summer cottage thing, mostly university professors, not much swank. It can get cool in the evenings. Don't bring a trunk. It's all rocks and we wear light canvas shoes with rubber soles.

You arrive at 8.15 a.m. and the Midland train leaves at 9.45 so we can get breakfast. No harm in bringing some large panels, a raincoat, it might be cool in the evenings. Just pray for fine weather to get to the Western Islands and wild woolly weather after we get there to make the painting good.

Everyone remarked on her happiness when she came back. I can even remember her enthusiasm when we were to go to the Georgian Bay ourselves, much later. But although it was a highlight in their lives, it was not to mark any great turning-point in their personal relationship. Neither of them could speak of their feelings. Jackson wrote a month later from the Browns' cottage;

Go Home Bay
August 17, 1933
Yesterday Frank and I and his secretary went up the shore in Peter as far as the bass rocks, stopping for lunch

The Little Pool (Georgian Bay, 1933)

on one of those poor deflated Pine Islands. We could see the Westerns like faint blue clouds, on the horizon. I guess the Westerns were just a dream and Anne Savage didn't really come up and sit round the camp fire and make sketches of bent pines and lichen-covered rocks.

I am only becoming conscious of it now. Isa says she liked you more every day she knew you. There are an awful lot of lakes up here and I would like to paddle you through all of them and make pancakes for you and coffee and shelter you against wind and rain and sun, you dear serene soul.

She did some good sketches, probably her best till then. Jackson wrote of them a few weeks later:

I hope the 'Little Pool' works out well. I think you could do something fine with the little twisted pines you did the day before we left. You handle greens with a lot of charm.

Later still (December 3, 1933) he was to write, with a sketch of the picture suggesting ways to improve it:

I wonder if you could do a little work on your Pool. It has fine things in it but it could hit harder. It could all be done in an hour.

The painting was sold to the Hamilton Art Gallery.

In 1975 it hung not far from the Jacksons, in the National Gallery show *Canadian Painting in the Thirties*. It is a big (31″ x 40″) canvas with beautifully formed peaked

rocks slanting down to a darkened pool. There is a curious emptiness about the picture as though nature in this case were not enough. Anne often peopled her canvases with trees. These seemed, in a sense, her friends. When the rocks stand alone it seems that there is something missing; perhaps she felt that way the day she painted it, or perhaps she was trying out a new style which gives the painting a "cubistic" look.

From his tent in the northern woods, in the late summer and autumn of 1933, A.Y. Jackson sent off letters full of question marks:

What do you want me to do Anne? You are the dearest and sweetest soul I know and if you will be my wife I will try so much to make you happy. If you want me to help you as you say it seems the only way to do it. We can go on being friends for the rest of our lives as we would no doubt. Whether marriage would mean perfect happiness or not it is no use being afraid of life

It's true I have a lot of dear girl friends Anne . . . Lil and Prue and Sarah and Frances, Florence and Isabel. I am very proud of their friendship and there is no reason for ever losing it. I expect you have a lot of responsibilities and it would be selfish to ask you to evade them but perhaps I could share them with you. Then Anne you are an artist too, with all kinds of fine qualities that will blossom out if you had half the chance that others have

I ought to go west Anne, to the great open prairies and forget about a lot of the unkind things I have thought about people round here, even if there is reason for it, it

Sketch of his tent by A.Y. Jackson (sent to ADS 1933)

only hurts one's self and that is why when I wanted so much to tell you that I loved you out on the Western Islands the words would not come. I should come dashing in from the western plains and sweep you off your feet because you're a darling

It is impossible to write this without a feeling of regret, for companionship lost and pictures unpainted. For Anne Savage, and many like her, these were the days of duty, real or imaginary. Anne had a mother to look after. Perhaps, though, she recognized in A.Y. a bachelor deeply committed to his painting, set in ways that would mean a rough and tumble life for her, and perhaps unendurable confinement for him. Fourteen years her senior, he did not seem likely to change. Whatever she said, his next letter sounded somewhat relieved. He agreed "to go on as they say in the army 'as you were' " but added:

I am going to walk home with you from the Baron Byng every day while I am clambering over these miles of hills and so the best of good wishes dear and may the bon dieu *keep on blessing you.*

This caring kept her going in the years to come and explains the love she threw into her work. The inspiration went both ways. A.Y. wrote her in the late fall of 1933: "Your letters up here have just made me so happy that any virtue to be found in the work I've done is due to you."

A.Y. Jackson and Anne Savage never stopped writing to each other. A few years later she was to sign off: "My heart stands still when I imagine existence without you."

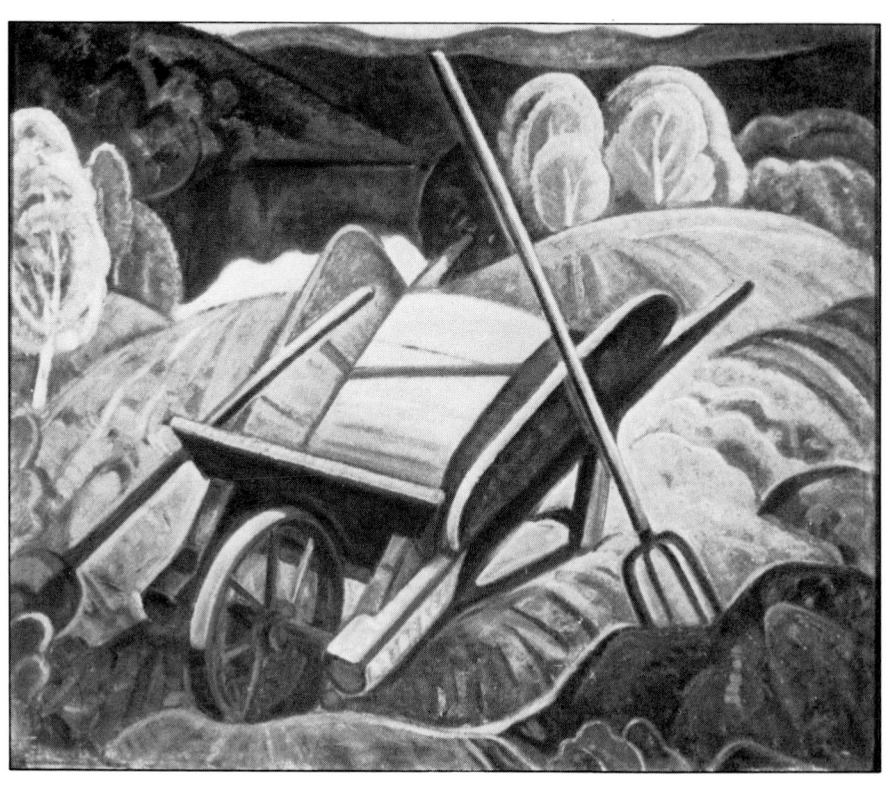

The Wheelbarrow, Wonish (1930's)

8
The
Family

Sir Raymond Unwin is here telling us what a mess our city is and it's pretty true. He asked me if I had painted our western prairies, he was greatly impressed with the vast feeling of space. Let's go Anne and paint them red.

AYJ to ADS, 21 November 1933

Jackson is speaking about the wide world of ideas all about him but he is writing to a woman locked into what westerners consider a choking eastern gentility. It was about the middle of her life when Anne Savage's family niche seems to have become a key factor in some of her decisions. What happened to her life happens to many single women if they stay home allowing family ties to override outside interests. In Anne Savage's case, consequences were both good and bad.

In the first place, circumstances made her more conscious of the clan than she probably would otherwise have been. The house she lived in on Highland Avenue was crammed with family treasures, including everything from uniforms and medals from the Boer War to a heavy set of antlers hung in the front porch. There were photographs lining the walls going back to the days of sailing captains in Scotland. As children we didn't like listening to their histories and so didn't realize who they were. It is only recently that I've read some of the writings of John Galt, the Scottish novelist and founder of the Canada Company, and traced some of Anne's characteristics back to him.

He was Anne Savage's great-grandfather on her mother's side. He was a bit of a dreamer about business matters. When he made the customary Scots' trip from Edinburgh down to London to make his fortune, he squandered most of his savings travelling around Europe with the poet Byron. He then wrote, frantically, *Annals of the Parish, The Entail,* and other novels, to pay his debts. His profits also enabled him to get married and have three sons. Galt didn't take his writing seriously although the

Scots people read him second after Sir Walter Scott. His books and poems are full of pawky humour, often in dialect, depicting village life. He always thought of himself as a businessman with great schemes.

Anne Savage was much more careful and thrifty than her great-grandfather and seldom gave in to her own love of adventure. It was when Galt came to Canada that he showed qualities that she later revealed. He was given the job of setting up the Canada Company and trying to settle the claims of many of the people who had moved up from the United States. He was generous and far-seeing in his judgments, as seen in his letters, but careless about paperwork with the authorities back in England and impatient with red tape. As a result, he didn't come out of the venture very well, and had to go back to Scotland where he ended his life, writing still, trying to pay off more debts.

His three sons, meanwhile, stayed in Canada where the youngest, Alexander Tilloch, become one of the Fathers of Confederation. The eldest of these boys was called John after his father and "Chopping John" by the people around Goderich, Ontario, for his prowess at chopping trees. He built a cabin on Lake Huron, about four miles from Goderich, and was appointed first registrar in the county of Huron. He apparently called himself "Registrar to the North Pole," for Huron in the early 1800's was not yet divided into Bruce and Grey counties and most of the land was uncleared. Settlers came in quickly.

John Galt never ran for election but took an interest in politics, once walking from Goderich to Toronto for the election of a man called Cayley. When he was twenty-six

he married Helen Lizars of Goderich, the daughter of an old Jewish family who had left France for Scotland many years before and then resettled in the new world. Galt used to go to his father-in-law's well stocked library to fill up his bag with books. Anne Savage's mother was the second child from this marriage. She had a sensitive, psychic streak which turned up in many of the Galts.

There is a story told about her brother Jack. It happened one evening in Goderich when their father, John Galt, was in Ottawa with his brother Alec and his father, Sir John. By this time John Galt was lame and walked with a stick. His son Jack, aged five, came running to his mother saying: "Dadda is home, I hear his whistle and stick on the verandah." "Nonsense," replied his mother, "You're dreaming. He's in Ottawa." She noted the day and hour and at that exact moment John Galt, who had climbed to the top of the Parliament Buildings, had died.

When Helen Galt married John Savage she brought a love of books and reading to the Savage household. It provided a counterfoil to the father's heavy emphasis on athletics and good sportsmanship, and affected all her daughters. Two of them married men of books and ideas and the third, Anne, was attracted to the quality of intellectual honesty in A.Y. Jackson. There's no evidence that Anne was closer to her mother than the others. She just happened to be the one at home when her mother needed looking after.

When the twins Annie and Don were born, a nurse, Margaret English, had come to the house at Dorval. As time went by she lost her own father and mother and stayed on with the family. She looked after many of the

domestic details, enabling Anne Savage to teach and paint, an interesting solution for women's liberation analysts who run into the problem of "who runs the house while you're out working?" Family retainers don't exist any more. Neither, of course, do many career women with the family obligations that Anne took on. The help she got at home, however, had one direct positive result. It made it possible for her to become a true professional in the field of teaching. For that she reaped a professional's reward. She was one of the first women to achieve this. These were the days when "career women" and "housewives" were two different creatures. Anne Savage would understand many of the problems encountered by women today who are combining both activities.

All during the thirties, forties and fifties she found herself at the heart of a busy, bustling family life which, if it did not include children of her own, at least provided interest. Her brothers-in-law were the main reason. Brooke Claxton left his law practice in Montreal to enter federal politics, giving the Highland Avenue address to his constituents. He became Minister of National Health and Welfare, Minister of National Defense and later the first director of the Canada Council. He was a big, gregarious man who loved to fill his house at Lake Wonish with his colleagues, whoever they were at the time. Meanwhile, just across the lake, Terry MacDermot had left his teaching post at McGill to work for a year for the League of Nations in Ottawa; then he became principal of Upper Canada College in Toronto. He too liked to bring people up to the lake, many of them as interested in education as Anne Savage was.

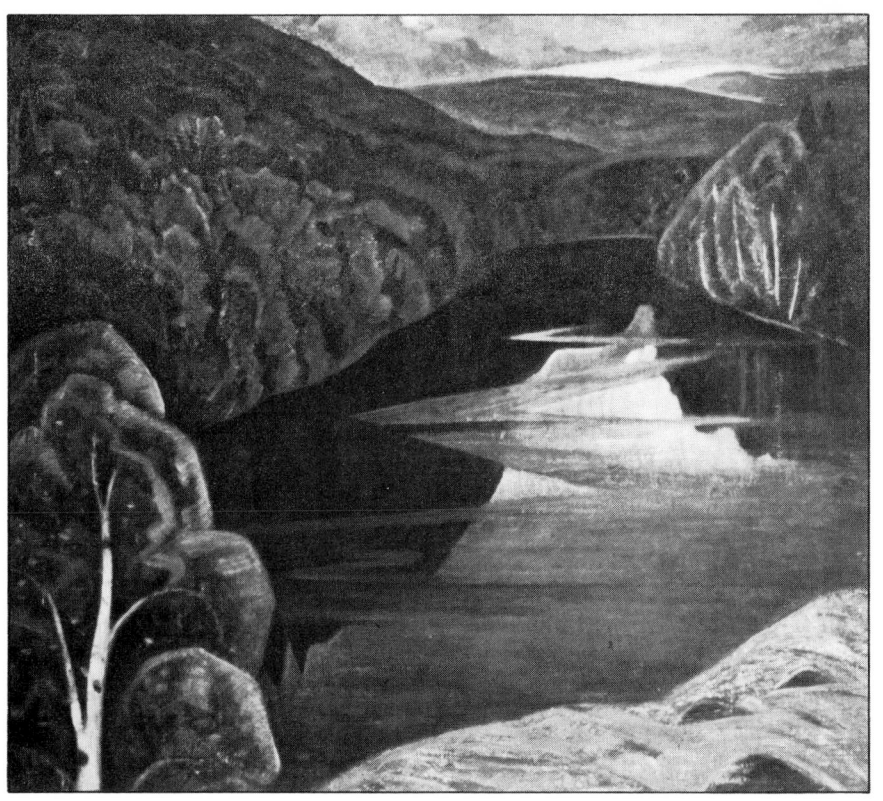

Lake at evening (1940's)

Summer weekends were hectic with people coming and going. There was a lot of conversation, picnicking and singing around the piano. There was not much to do in an organized way but one of the places to visit was Anne Savage's studio.

It is a pretty place. The little house was built up on a rock with a verandah running across the front, a crab-apple tree to one side and wild rosebushes all around. It was deliberately built high so that Anne's view would be clear to the lake. She could only see the tip end of it but that happens to be the sunlit corner. The number of times she painted it show what seems to be a dozen lakes all different in mood and atmosphere.

She used to stand her easel by the front window where the light came over her left shoulder. She would hold one brush in her teeth while reaching with a finer one for a new colour. She was quick and deft and unfussy in her movements; mixing turpentine, flourishing a rag to clean her palette, and standing back, squinting, to get a better perspective. She always had a mirror, in fact the studio room had three mirrors, and she found that seeing the reflected version of the canvas helped her in composition.

The fields between the studio and the water fold into valleys at the foot of elm and maple trees. There is a road running across the end of the fields that turns by a clump of maple trees. Anne found the view satisfying. It contained the elements of rhythm and design that she needed, and was right there in front of her. The fact that she painted it so many times in later life instead of "working up" the sketches she kept piled in a cupboard in Highland Avenue is reminiscent of the habits of many Impressionist

painters. Followers of Monet took their inspiration from the light. When the light shifted the least bit they waited for the same time next day to continue painting. Anne Savage was not such a purist. When she was working on a big canvas from a sketch, for instance, she often went on steadily and stubbornly past a point where she and others knew she should have left it. This is one reason why her sketches, done under the ruthless discipline of time limitations, are her most exciting work. It is also why "Anne's lake," as her friends called it, so often gave her the inspiration she needed for on-the-spot subject matter. She turned to it again and again.

As children we only caught glimpses of her actually painting. When we ran over to the studio she would either greet us and immediately tell us that she was finishing something and would meet us at swim-time or else put her brushes away and give us something to do. She had plenty of time to decide which it would be. There's a wide field in front of the house and she could see us coming long before we got there. When the morning went to us, we found there were things ready for us, such as lino blocks for Christmas cards and a box of the proper tools to cut them. She would describe possible designs for Christmas so skilfully that we thought we had chosen our own. We got excited about the tree, the star, the crèche, and would settle down in the bright room with a great feeling of contentment, the sun streaming through the skylight, crickets and bees buzzing in the summer heat and hummingbirds coming to the bergamot and delphiniums in the garden outside. We probably picked up some of the happiness she always felt in having a place of her own to

paint. At any rate there was no nagging in the studio, no one "bringing us up."

When we made Christmas cards she took us right through the whole process and we inked out the finished product. Although she brought these materials up deliberately to help keep children in the country busy, Anne Savage never really liked the arts and crafts side of art as much as she did drawing and painting. If we wanted to get out poster paint and sheets of paper, she would teach us how to get started: to look for the big shape first, not to be afraid to fill the whole space and put in the details afterwards with colour and shade to get patterns. She did not drag us along. She left us wanting more direction, not less. She had a showbiz sense of timing, and a real love of theatre. She used to help with ideas for circuses, the shows children stage in every country garage at every summer cottage. There were boys balancing on barrels, clowns, and a kind of puppet show when she helped us make the puppets. These shows became a highlight for us because she thought them important.

In these summers Anne Savage would put away the smocks that were a trademark in her students' eyes and get into shorts and a blue linen shirt. When it was cold she wore blue jeans and a grey sweater. The jeans were really an early version of the hippies' uniform.

She didn't forget the students' work and the walls of her studio, as well as her sisters' houses, were hung with the best drawings and paintings of that year. We used to look at them and wonder who the artists were. The best of this work was collected and given to Sir George Williams University for its Fine Arts Library.

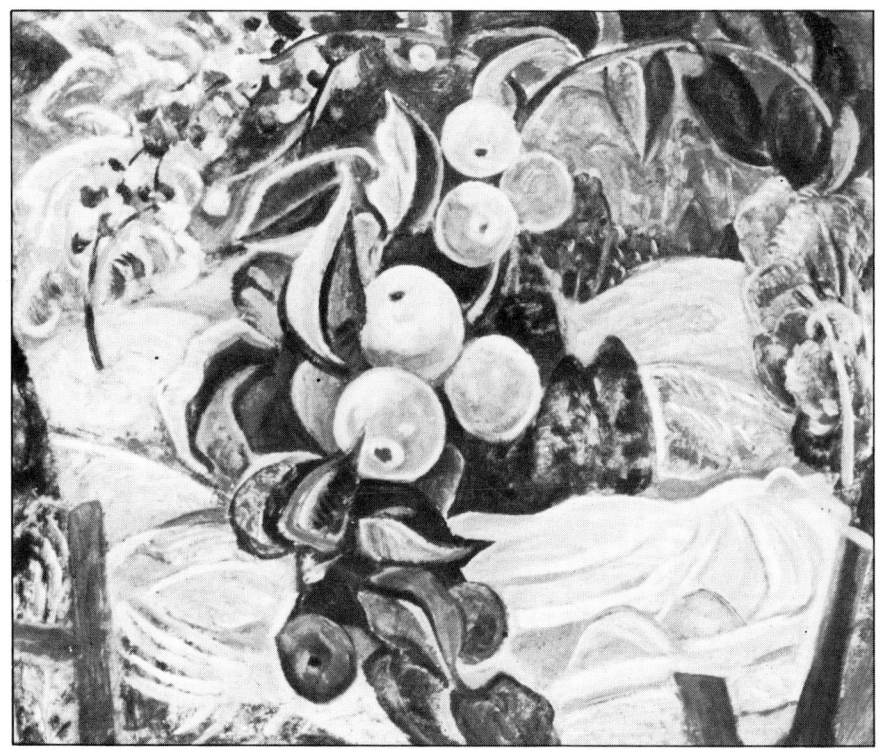

Early Apples (Wonish, 1950's)

Anne Savage never pretended Lake Wonish was the only subject to paint. She told Arthur Calvin:

I had friends who came up and they couldn't do it at all. They found it too compact without enough variety. It's true you get more motifs in the Eastern Townships with the open, rolling hills. But the Laurentians have an intimacy, at least this little lake has, and you can get beautiful closeups of birches, wild apple trees, sunflowers. It made me dig deeper to find something to paint.

On the weekends a stream of visitors came to Wonish. Politicians, historians, journalists, university professors, painters and sculptors got to know her and her painting. Her pictures got further exposure when the MacDermots were sent abroad to South Africa, Greece, Israel and Australia. Elizabeth MacDermot would send paintings ahead to remind her of home when she arrived.

The gang at Wonish filled a great part of Anne Savage's life. She might have found more fulfillment elsewhere. Her studio did not have the privacy an artist craves but it would have been out of the question for her to build anywhere else, originally for financial reasons, later for emotional ones.

There were as many people going through her house on Highland Avenue. She provided headquarters here for her nieces and nephews going to McGill. This is why, when she writes to A.Y., many of her letters talk about "we." She means the close family circle, her sisters and their children, that were always there for Christmas, turned up for Sunday dinner, rang from airports or train stations

when stranded in town, and often lived at "Highland" for months at a time.

It brought her sadness as well as joy. There were good years when her nephew John Claxton took his McGill law course, living at Highland, and then married Patricia Carson. His sister, Helen Jane ("Boo") also took her BA at McGill. David Claxton, the second boy, came to live with Anne Savage when he was studying medicine. Tragedy struck the summer he was drowned in Labrador. She wrote A.Y. on June 22, 1952.

Thank you for your message, how well you know how to express it

He was an unusual boy, joyous and giving and kind, he seemed to be the liaison officer for the family circle. The MacDermots would do anything for Dave and vice versa. . . . The doctor at Seven Islands really depended on his help even though he had no medical experience. He was able and willing and adored the life and he was as happy as the day is long.

Everyone is feeling much better and the rush and turmoil will soon sweep Helen and Brooke along, Helen forever bereft

Goodnight my dear and look after yourself. This whole life is a dream we will waken from some day and then everything will be clear.

ever —
Anne

It was a happier time when another nephew, Galt Mac-Dermot, went to live at Highland Avenue before getting

his own studio in Montreal. It was in 1954, long before he wrote the hit show *Hair* which Anne Savage was too ill by then to see. He had a job as an organist and did a lot of composing, anthems as well as musical comedy, on the Highland piano. As an artist, he found her extraordinary. "Aunt Annie *always* knew a good tune," he says, "In teaching, in performing, she was great. I don't like all her pictures but she had a kind of indefinable magic in some of them which I can only call music. If you could define it, it wouldn't be there. She never defined it, perhaps she couldn't. In a way she was too pure about painting, she wouldn't define the thing that worked and then concentrate on it and work it up and make people recognize it. I used to throw away tunes like that and it doesn't work. You have to tell people they are good. Jackson did that, he repeated something until he got it perfect and then he sold it over and over again.

"She was surefire in recognizing a tune. She came to a play I did once with Bill Edwards [the Toronto writer who later made the movie *Married Couple*]. No one could sing the music at rehearsal, so she did the tune, you know her funny voice, and it was magic, until she stopped singing — then the music went out.

"I think she and Jackson had the same obsession for painting. They both stuck to their medium, you have to. When Jackson went to his paintbox he felt he was doing the right thing for him. Aunt Annie got distracted with family things but she followed this passion a different way, through the children's classes.

"But she didn't get caught, she had to fight to stay out of the conventions. On the whole she won her fight, went

Balcony of 'Kilmarnock' at Lake Wonish L. to R.: Anne Savage,
Galt MacDermot, A.Y. Jackson, David Hughson

her own way. Probably Jackson turned to her for criticism because she was such a pure artist. She never used any other criterion."

He added that he felt Jackson and Anne Savage were both looking for the same thing; as Duke Ellington would put it, "looking for the melody." They were companions along the way. He said: "You know how artists need to talk to each other."

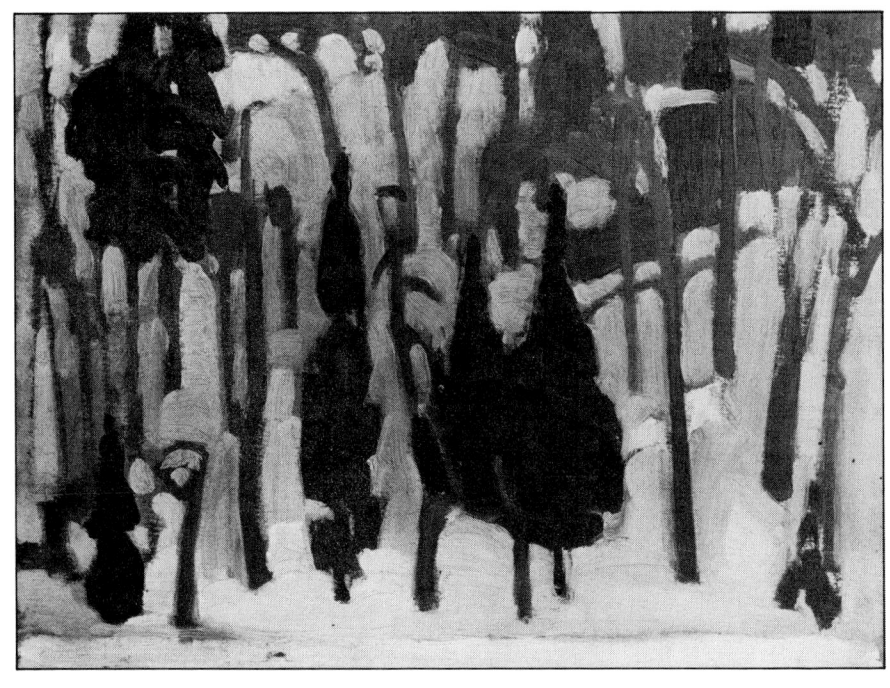

Untitled Winter landscape (Wonish 1920's)

9
Branching Out

Spent Thanksgiving in New York
and the Museum of Modern Art...
Not big canvases but so much
bigness in a rather small space.

AYJ to ADS, 18 October 1936

There is every reason to think that these two artists kept on writing to each other for the next five years, but 1933 marks the gap in Anne Savage's collection of letters from A.Y. It is a tidy cut, stopping with a letter dated Dec. 17, 1933 and resuming with one from Jan. 8, 1939. In between are the two dated August 31, 1937 and Sept. 1, 1937.

As for the letters which A.Y. Jackson kept from Anne Savage, there are about two to six for each year of their long correspondence. The painting, meanwhile, never stops. As an artist, Anne was growing up. The energy and emotion that other women were putting into marriage went into her painting, as it always had.

She sent a picture to the Canadian Group's show at Atlantic City in 1933. The NY *Herald Tribune* noted the decorative landscape painting but regretted there were "few painters of robust and telling vitality." The NY *American* liked "a fundamental integrity" but the Canadian critic Augustus Bridle of *The Toronto Star* wrote: "If this group does not paint people, it too will have to dissolve into something more humanly Canadian."

Anne Savage was occasionally singled out for what the art critic Graham McInnes calls "the limpid, lyric quality" of her work. "Green Shores" was welcomed at the Edmonton exhibition of the Canadian Group in 1936 as "relief from the relentless virility of the earlier Group of Seven." Like the "Little Pool," the picture has an empty quality but here, instead of loneliness, there is a sunlit sense of happiness, benign and content. The lake is Wonish. It is painted from the front lawn of the old log house, Kilmarnock. The hills are emerald green. The line

against the lake, of course, is pink.

Jacques de Tonnacour, a Montreal member of the Canadian Group for many years, says the women painting at this time found it difficult not to be derivative of the Group of Seven. The pressure was on them to do landscapes and when they did they were competing with the massive paintings of the senior men.

Anne spoke to this point, on one occasion, noting that while most people took it for granted that the strenuous work in developing art in Canada was done by men, Prudence Heward and Emily Carr were strong women painters in their own right. Later she named Marian Scott as the outstanding woman painter working in the experimental abstract field. As for prejudice, she only said that painting was a full time job. She thought that the only handicap women might have came from having to devote time to things like housekeeping.

During these years Anne Savage seems to have discovered or developed a talent that she may not have realized she had. It was the talent to hold audiences, not only schoolchildren, in thrall before her own love of painting. It was the quality of showmanship. It came from her own inspiration, which is what led Leah Sherman to compare her with a minister. It was what made her an exciting teacher. It was often straight theatre.

A.Y. seldom saw this side of her. As a single-minded artist, he probably didn't approve of the time she took away from painting. Friends in Montreal caught glimpses of it from time to time. Lilias Newton says: "I remember when Anne opened the Prudence Heward Memorial show. She looked so lovely in a long black velvet dress. I

can still see her. It was a difficult thing to do for a friend that had just died. She was not in the least self-conscious and I remember thinking this must be how she teaches."

By 1935, her reputation had spread beyond Baron Byng and she was asked to speak at the National Gallery in Ottawa as well as at art societies in Quebec City and Montreal. These were the days before common use of what are now called "audio-visual aids," but Alfred Pinsky remembers: "Very early on Anne Savage got one of those opaque projectors. She could throw up reproductions and leaves and all kinds of things. But she used it a long, long time ago, a technique that only later began to be used extensively."

Her subject matter was just as advanced as her equipment, for those days. From her announced topic, "The Development of Art," she would take her audiences into the story of Canada's own painting. Many of them had no idea such a thing existed. But Anne Savage had a very personal quality that she revealed when telling others about something she had discovered and loved herself. While she could be crisp about other things (although we never noticed this until much later), she was grateful to have found her world through painting and very gentle in introducing others to it. She gave the impression that this magic had nothing to do with herself. It was an inheritance for all who wanted to seek it. She never talked about her own painting, for instance. She did talk about her friends, other painters, A.Y. Jackson. In delivery and charm she was like today's poet, P.K. Page, reading her own work. Anne Savage's gentle, subtle way of expressing what an artist was

trying to say was like Sir Kenneth Clark's when, for instance, he speaks about Claude Monet's treatment of water and makes his audience see the play of light through the waves.

In years to come, when art became so international as to make nationalism almost unbelievable as an inspiration for painting, Anne Savage was to acknowledge the new drives for self-expression and the changes they brought to the form and content of Canadian painting. But her own particular subject, what she knew best, was what she called the "spirit of the original Group of Seven to interpret the Canadian scene in all its variations."

Her letters to A.Y. at this time are full of professional as well as personal sidelights on their painting friends. On September 10, 1935, for instance, she wrote him: "I heard Sarah [Robertson] has a new pallette knife technique, quite interesting" and that same year,

Kay Morris came back and we all gathered to see the results of her trip. She had some very fine sketches of Quebec scenes, very solidly painted. She is so genuine and true in character, her work seems to have developed into something richer.

In October, 1936, she wrote:

Poor Lilias [Newton] has had a hard struggle with the portrait ['Queenie' MacDermot]. It just didn't come off. I think it is the mouth and also a tendency she has of making massive shoulders. Yours wasn't so bad, you can take it, but Q. can't stand it. Lilias was let down and

when we came in Q. admired the lilies in the hall. She
immediately took them off the wall and gave them to her,
charming of Lilias and so fine.

The following summer Lilias Newton visited Lake Wonish
and Anne wrote:

It was too hot, we couldn't sketch, but she did a series
of flower studies and I learned a lot. I was finishing up a
little head of Mary [MacDermot, her niece]. There is
nothing like a portrait to make you model.

The earlier portrait was not forgotten:

Lilias made a sketch of the lake and hills and she was so
excited and interested. She doesn't do much outdoor
work. And she is going to use it for the background of Q's
portrait. She has difficulty with settings, but her ability to
grasp the essence of the form and mass is thrilling. She
treats landscape in a different way, gets a fine volume.

Anne moved about a bit in these years, enjoying the
occasional trip to New York. From the Eastern Townships
she wrote, October 1938:

We got in tonight after a very happy visit at Foster
Nora [Collyer] did some fine things this week. She seems
to have suddenly found herself.

There is a special quality to Anne's own work from the
Townships. She applies paint liberally to get a chunky bold

effect. The fences are solid and timelessly graceful and the hayricks, old wagons and heavy wheels that she discovered by the barns are well modelled and classic in proportion.

She wrote in concern about two other friends, the Toronto sculptors Florence Wyle and Frances Loring. They lived picturesquely, but usually precariously, in an old church in Toronto. She asked A.Y., August 22, 1937:

What about doing something for Frances and Florence in the furnace line before another winter hits them. I don't think we should all sit down and let them struggle with the cold and damp of that place. Why not first talk them into it and then we can all get busy and beg, borrow or steal the money.

On August 31st (in one of the only two letters from this period) he replied:

I spoke to Keith [MacIver] about a furnace. He is waiting until he can take someone up while the girls are away and get an estimate.

As for Jackson's own life, it was made hectic by more commissions than he could fill. She wrote, May 11, 1936, trying to help with a decision about a possible move:

Dear Alex,
I was so glad to hear of your successful visit to Ottawa. That is fine and there will be some hope now for Mr. Lismer [away working in S. Africa]. It was lovely of Keith and the Peppers to try and arrange a move for you. How

grand to have that all done for one. I think I know how you feel about conditions there. It is an old story, as it were, and you want a change and why not have it. It is difficult to decide, you get pulled both ways, you poor dear. You'd never hesitate on account of me, the thought would make me very unhappy. Do what you feel is right from the point of view of your work, and as you say facts have to be faced, there is a field of interest here and Montreal has gone on a long time since you left it. Living is more expensive, I imagine, and yet I think you might be happier if you weren't constantly reminded of the old days, there are worlds to conquer yet and grand work to be done and why remiss over the past which has gone but not vanished. All that experience to be built upon, don't be despondent, Alex, you are winning. The step wouldn't be irrevocable, you could try it out and it might do us all good.

"Remiss" is her own word, not quite the one she needed; this groping for words is one of her more endearing characteristics.

Then she adds what may be the giveaway to her whole struggle. It's the conflict between high-mindedness, or what she thought was the unselfish thing to do, and her own real feelings:

. . . Dear Alec, I wonder if you can understand me when I say I am the most dishonest person who ever lived.

John Astbury, head of Baron Byng and sympathetic to Anne Savage's new ideas, recalls this period: "Anne Savage

was a big person in this city. Everyone knew her and admired her." And then he remembered other more human things: "She did our Christmas card every year for us and taught our daughter after school on Tuesdays. I remember when she got her first car. She was scared driving along Pine Avenue. I said to her 'just get in there and so what if you get a scrape, you can get it fixed. Just drive that way. Don't be frightened.' And she did and was fine from then on."

Her first car meant a great deal to her and brought a sense of freedom she had never known. Jackson, who always wished she had this freedom, wrote of a car more than once. In a letter of November 23, 1933, for instance, he says:

My studio is at present the temporary office of the Crown Tiblemont Mining Company and Keith MacIver and Peter Swanson are all excitement about getting a company. Swanson is as breezy as ever and wonders why businessmen only think of the money side of things. He wants to get a mine going and the money is a mere incident. All I care about it is I would like to get you a car, then you would have more time and you could take your friends out.

Many people dropped in to see Anne Savage at Baron Byng. She had a flamboyant visitor in her art room one day. Dr. Norman Bethune was operating on TB patients at the Royal Victoria Hospital at this time. He used to paint for relaxation. He also turned over his Montreal apartment to

the artist-teacher Fritz Brandtner, who held children's classes there every Saturday morning. Without warning Bethune walked down the hill from the Royal Victoria one day to Baron Byng. He said to the art teacher: "What do you do in this class?"

It was an encounter between two Canadians from strait-laced backgrounds, one of whom went to extraordinary lengths to break out of the nets of convention, while the other turned down bohemian life for the orderliness of the school room. The Anne Savage who told the story was not the beautiful young woman who met Bethune years before. As she told it, both the incident and the recollection troubled her.

She half-acknowledged her "squareness" in the Calvin interview when talking about two other bohemians, Florence Wyle and Frances Loring. The church where these two lived in midtown Toronto was a dropping-in place for dozens of artists, poets and musicians. So was the farm they bought just outside Toronto. Anne described it:

Everybody would come and just spend the night and if anybody had nowhere to go for the weekend they would go to 'The Girls.' They would bring their mattress or sleeping bag. It was complete bohemianism as I never saw it before. And it worked because the spirit was that nobody would take advantage of anybody else. They were a fine crowd. And they talked. I went out one afternoon. I didn't stay overnight.

In 1937, Anne Savage met a new challenge. For some years

Frances Loring and A.Y. Jackson (1952)

the Art Association of Montreal had been slipping and the Board of Trustees appointed Dr. C.F. Martin, former dean of medicine at McGill, to put some new life into it. He turned to three of the original Beaver Hall Hill painters for help. Edwin Holgate and Lilias Newton were asked to start painting classes for intermediate and advanced painters. Anne Savage was called in to start classes on Saturday mornings for the children of Montreal.

On August 22, she wrote Jackson excitedly as she might have written her father:

I had a most excellent time with Dr. Martin the other morning. He is as keenly interested as he can be and wants to wake the place up. . . . Most certainly Arthur Lismer should be there and we may be able to work around, so much is going to develop that it can't be done piece-meal. I hope to heaven I can manage my end of it. They are cleaning out the basement and putting in cloak-room space, etc. and getting it ready for modelling and there will be a screen put down there and we'll run the lantern for short talks. . . . Besides the Saturday morning class I have to arrange for talks for the Members' children. They thought it might encourage membership. As far as I can make out all the Members only possess grandchildren or great-grandchildren, but do anything to break the ice.

A.Y. replied:

You will have an interesting time at the Art Gallery. Dr. Martin sounds good. He will have to be very tactful or he

will alarm a lot of the old fossils who look on art as a polite little hobby and who resent the intrusion of living artists on the scene.

What a difference from the lively places art galleries are today. Jackson need not have worried about the younger generation, however.

"Children's Hour," as it was rather solemnly called, drew kids in droves. Children from nine to fifteen were invited to come, free of charge, to paint or model. Although the classes were given good press coverage when they opened, no one was sure how many would choose to give up their Saturday mornings. They came swarming up the broad steps of the Gallery on Sherbrooke Street to spend a morning engrossed in poster paint, brown paper panels, or clay. Within the first year the classes were filled and a waiting-list started. After that the *Montreal Gazette* announced that it would be necessary "to show work in competition in order to get in."

Ethel Seath, art teacher at "The Study" girls' school, was in charge of the modelling, and Paige Pinneo and Audrey Taylor, two art teachers, were asked to help with the painting. The Gallery classes couldn't cope with the demand and Anne Savage opened Saturday classes in the public schools, using the gymnasiums for painting sessions.

She asked Alfred Pinsky, still a pupil himself in those days, to give her a hand with the public schools by running a couple of the classes. He remembers that during this period his supervisor would reach into her purse to pay for the turpentine and varsol he and other students needed.

From this association the Child Art Council was developed, which in turn became the Quebec Society for Education Through Art. The Council was significant because it was attended by a number of French Canadian art teachers, trained at the Ecole des Beaux Arts. Outstanding among them was Irène Sénécal, a Montreal painter teaching art at the Commission des Ecoles de Montréal as well as the Beaux Arts. These were the days when points of contact between the two language groups were rare. Furthermore, French art education, now ranked ahead of the English, was then slumbering along with a mediaeval system of public education. Miss Sénécal and Anne Savage shared a flair for teaching, as well as a spirit of cooperation which gave the Council special value.

At Baron Byng Anne was teaching full classes of boys. She got them to decorate the school basement. The locker room atmosphere was swept away in a blaze of murals which used the bricks and pipes as a dramatic part of the design. The students were proud of the achievement. It made the school a showplace.

The summer after starting the Saturday morning classes, Anne Savage was asked to give a class to art teachers at the Southern Alberta Institute of Technology in Calgary and the School for Teachers in Edmonton. She came back with sketches of a Prairie town with telephone poles and power lines interlaced among the straight angular houses.

By 1939, Jackson's letters reappear. He is talking about war clouds. Ironically it is she this time who picks up the story of Canadian painting, the story he had inspired her and many others with after the last war. She was asked to give a series of eight talks on the Development of Art in

Canada for the CBC. Carried on national hook-up, they ran from January 6 to February 24, 1939.

In Toronto, we were called to the radio to hear the talks. We had been gathered around the same radio to hear King Edward VIII abdicate, and we listened to Anne with about the same amount of interest as we had the King's speech. She was apparently nervous about the microphone at first and to us her voice did sound a bit high and formal, but she drew courage from her outside editor, A.Y. Jackson.

The typescripts of the broadcasts show the considerable knowledge of art history that supported the charm and showmanship of the teacher. She traces the Canadians' Anglo-Saxon love of landscape to the English painter, Constable. Up against an eighteenth century patron who believed that "a good picture, like a good fiddle, should be brown," young Constable worked out "small studies that used the principles of Impressionism to bring together tone and colour in a new and unexpected harmony."

The first Canadian painter she mentions, Paul Kane, took a different tack, however, and studied in France so that he could return to his native York and make better paintings of the Indians whom he had watched bringing down their yearly supply of furs. Using European realism, he built up a unique historical record of Indians in the East and on the Pacific Coast. Kreighoff, a young German immigrant, painted the convivial family life of his French Canadian wife in Quebec. Anne describes "the log house, with the winter supply of wood piled at the back, the well with the buckets, and the odd chicken at the front door, the small pink sleigh, packed full as usual, stopping for a moment's chat with a neighbour on snow-shoes."

Then she spoke about the mysterious James Wilson Morrice, the young Montrealer trained to be a lawyer, who studied in Paris and brought Impressionism to Canada. Travelling back and forth, he would sketch in Montmartre, then return to the St. Lawrence, and with pure colour would use wooden panels to paint snow in a glistening mixture of purples, violets and ochres.

In these talks Anne Savage does a curious thing. She speaks to her audience as if she too knew little about art and was, like them, looking for something to hang on her walls. She does not tell listeners that she is a painter herself.

Perhaps a better view of the talks comes from the image of them that survives in the letters of the tireless Jackson.

January 8, 1939

Your broadcast came through clear as a bell, so you are off to a good start. It was a good way to start the series too by the little talk on Constable. He and Thomson are closely related in their love of the weather and the out of doors.

January 15, 1939

The second broadcast came through perfectly. It was direct and simply stated and gives one a very just picture of Kane. It is quite a little job you have undertaken. Krieghoff should be good material. He is a picturesque figure. You will depend largely on the Marius Barbeau book but you will have to be a little careful as a lot of it is just fiction. . . . Barbeau has a big scrapbook of mine at Ottawa, all kinds of stuff in it. If you wish I will have him

of a Canadian Painter

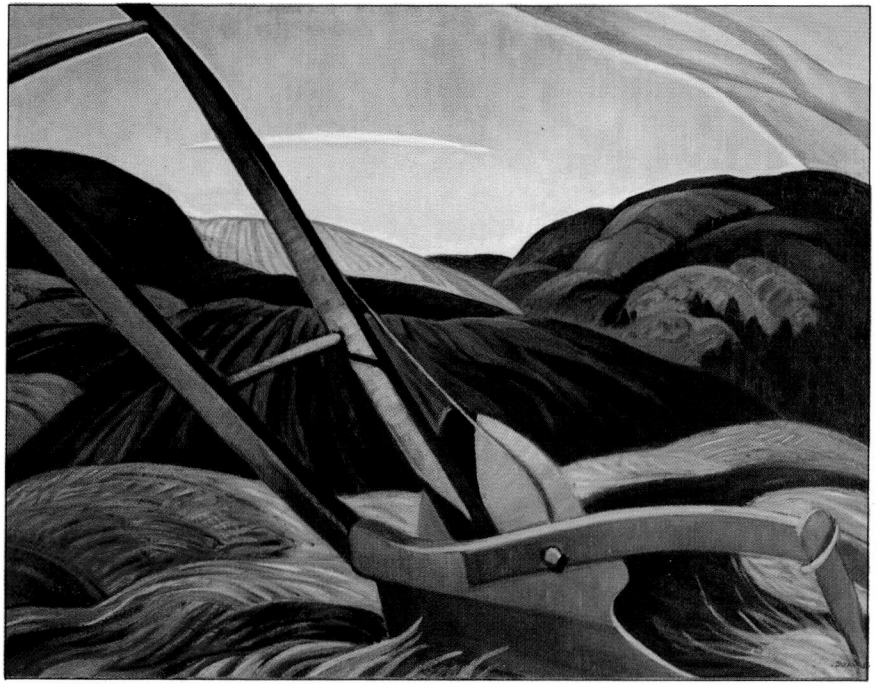

The Plough (1931)

Anne Savage: Story

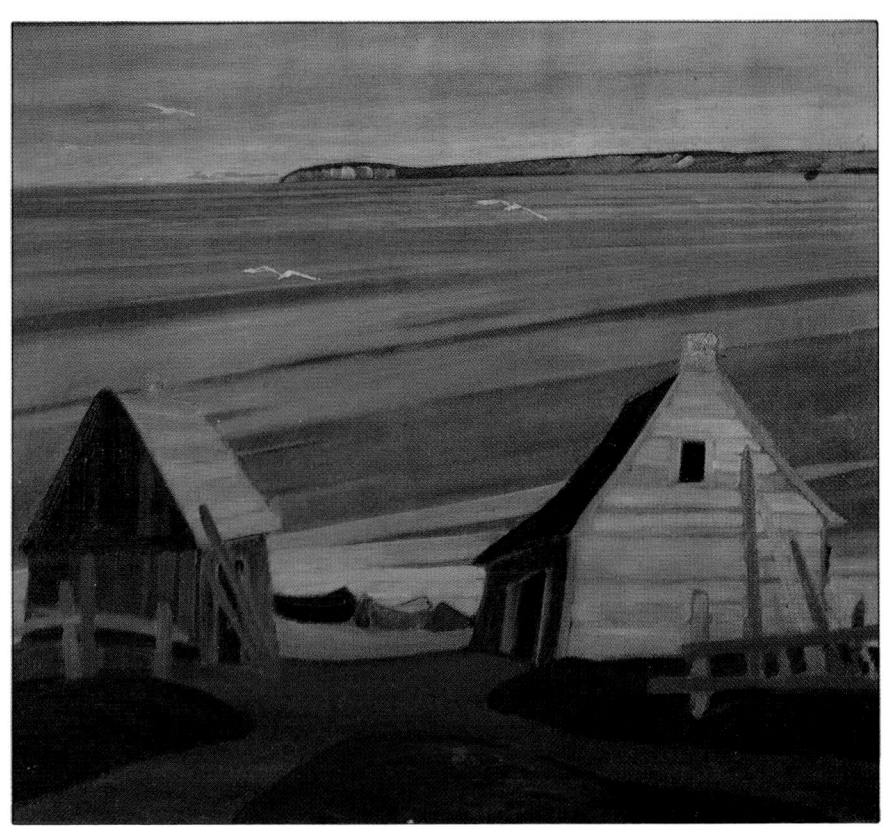

Shacks at Gaspé (1931)

express it down to you. You might find material for some of the later broadcasts, Morrice and Cullen might be worked together. I have an idea there is an article in my scrapbook that Barbeau wrote on Morrice and Thomson. It was good stuff.

January 21, 1939
 Your Krieghoff broadcast came through beautifully, clear as a bell. I was quite surprised how quickly the time went. . . . Yes, Thomson's 'West Wind' was painted in his last year. He was no longer satisfied with pattern. You feel in this canvas his forms are becoming solid with space around them. Have you a copy of my April broadcast, if not I can send you one. Thomson and Morrice make an interesting comparison, between the cosmopolitan, experienced and technically trained Morrice, and the other with his roots deep in the soil of his own country and mostly intuition to guide him.

Halfway through the series, she wrote gratefully:

I have written the Thomson talk and did it without the [Blodwen] Davies book. I had lent it. I wish you would check it. I have a feeling the people who would take the trouble to listen in are just interested laymen and so I have simplified them as one would for a child, and yet I don't want to over-dramatize them or yet not give them their proper significance. If you think it too soft say so.

Later, in the same letter, she went on:

*I have combined MacDonald and Harris, and thought
of combining you and Lismer, as the final workers in the
country, leaving out Varley; and then in the final one
bringing in the development . . . or would you rather be
with Harris? Thank you for the paragraph for the Morrice
one, and the excellent little improvements in such words
as 'cloud,' etc. By the time I finish I won't mind the
microphone in the least — and then some painting. I'll
return the portfolio as soon as I am through. With many,
many thanks, Anne.*

Jackson wound up his comments with the following
sequence:

January 26, 1939
 *Have messed up your broadcast somewhat. It's your
chronology that is a little twisted, not to be wondered at
as it all happened when you were a mere child. You mixed
up 'A Northern Lake' which Thomson painted before I
knew him and 'A Northern River,' painted while I was
overseas. Just what happened during the war I don't
know. Thomson wanted to enlist, but MacCallum was
very much opposed to it and he was very unhappy about
it all.
 . . . You have a picture of us all sitting around sketching
and Thomson watching us. At various times he worked
with Lismer, Harris and me, but no parties of artists. The
last page is good. I hope I have not mixed it up.*

February 3, 1939
 Went over your broadcast additions, hope they are

readable. Harris is not easy to write about. The first paragraph gave a wrong impression. He did not finance the group. It would have spoiled everything. He may have given Tom an odd canvas in exchange for a sketch or two. He did help MacDonald when he was ill and almost destitute, but the only one who took advantage of him was one of our noble academicians, Williamson.

Jackson listened that night and added this:

Just been listening to the broadcast. It came through beautifully, quite the best one to date, good introduction, lots of information and a good ending. I sent the manuscript on this morning by registered mail. There are a few little things to clear up, one or two repetitions like yours truly enlisting, don't have me enlisting again, just say 'A.Y. off to the wars.'

On February 16, he wrote her twice, first with these comments:

It's a dull dark morning, a good time to go over your broadcast. It sounds OK and I have only expanded the Lismer part of it, a little too much on his educational work and not enough on him as a painter. And I have softened down a couple of parts where the limelight gets too strong on me. It is always more effective to understate.
There are so many different points of view. Graham McInnes thinks Milne our greatest artist, others think Schaefer. The Art Gallery officers think Gagnon is, so it is

best to allow them all to have their own ideas. The same thing applies to the comparison with Morrice. I always regard him with admiration and felt pride in the fact of his being a Canadian.

It has been a lot of hard work for you. You cannot tell just what the results will be, a lot of people find it a difficult hour to listen in. I had a letter from Bill Wood, he has been enjoying them, you just don't know. It is a case of casting your bread upon the waters.

And in the second letter these remarks:

I thought the last broadcast came through very well and tomorrow's should be equally good. The Art Centre are anxious to hear what you have to say about A. L. I have not received any manuscript from Terry [MacDermot] today so presume as it is of a general nature you knew your ground pretty well.

One would expect hymns of praise for her beloved Group of Seven. Sure enough she reaches Celtic poetic heights, worthy of old John Galt. But she shows a teacher's fair-mindedness with her favorites. Of Jackson she says: "He exemplifies the Constable tradition of close observation of the outdoor world; he never falls into the theatrical vein; he depends for his drama on the quality of the conditions which he finds." Speaking of Arthur Lismer, she steers clear of controversy, giving credit to the man who helped inspire her in her own teaching: "I shall never forget dropping in one morning to the Toronto Art Gallery and seeing a whole room full of energetic small people sitting on

the floor painting away to their heart's content."

She wraps up the talks with a summing up of painting since the Group of Seven. It is significant that she does not mention French Canadian painting. This was the English network and in those days, before the Quiet Revolution in Quebec, there was little interchange of ideas. Alfred Pellan would change all that.

A.Y. concluded: "The final broadcast came through very well. It was a good generous summing up. . . . "

Nothing stands still in the painting world and in 1939 a new group came into existence to challenge the once revolutionary Canadian Group of Painters. Under its president John Lyman and vice-president, Paul-Emile Borduas, the Contemporary Arts Society set out to foster what was "vital and actual, championing no particular school or tendency." Anne Savage was listed as one of the original members.

In the fall of 1939 Anne Savage went back to Baron Byng just as war was declared. Jackson wrote, (September 7, 1939) for once acknowledging the satisfaction of a job such as hers: "Today you will be sizing up the kind of youngsters you will have to work with. It's a pretty grim world they have to face," and later, "How is school? I suppose there is a certain satisfaction doing work when the results are so evident."

What had been for her, on the whole, the bright thirties, came to a sombre end in war, very much as her life had been darkened once before. War was not likely to directly rob the family of a loved one but it would touch all their lives, of that she could be sure.

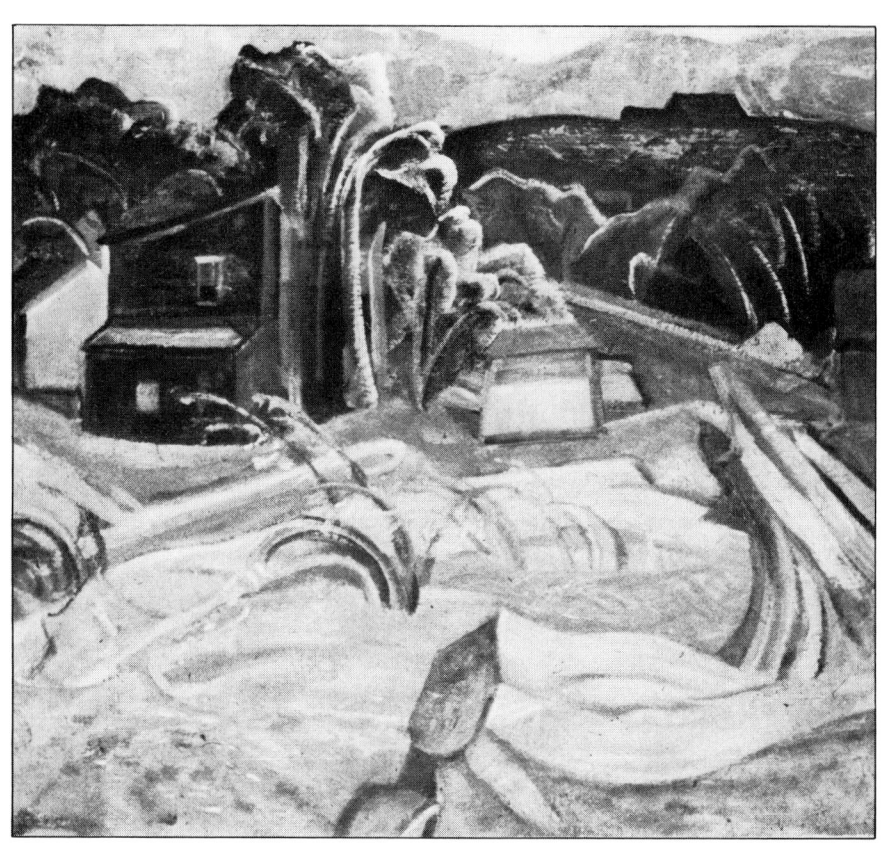

Untitled Oil Sketch, (Métis, 1930's)

10

Outbreak of War, 1939

The only thing to do is paint, that is what the world needs, more artists.

AYJ to ADS, 1 September 1939

The Second World War was to bring A.Y. Jackson and Anne Savage close, closer perhaps than they had been before, closer than they were to be again. It was a time of reappraisal for many people. It was a summing up time, especially for the two artists, both past middle age but at the height of their powers.

Jackson and Anne Savage had their own reasons for remembering the First World War and dreading the second. Jackson was disillusioned by the political situation and the apparent dismissal of everything he and his generation had fought for. For Anne Savage it was a time to remember the early loss of her brother. Jackson stuck to his painting and wrote her to do the same.

She did. This was the time in her life when everything she did was going full tilt. Graduates of Baron Byng today look back on these as "the golden years" at that school. The students were bright and competitive. Their marks were the highest in the province. The art room reflected this energy. Meantime the Saturday morning classes were overflowing. Her activity as a teacher seemed to galvanize Anne's work as a painter. She was now recognized as a ranking woman painter in Canada.

With other Montreal artists, she sent canvases to an auction for a Spanish orphanage in 1938 as well as to the "Committee for Aid to Spanish Democracy" later that same year. The year 1939 marked a peak in her painting career. As the invitations came in, she had pictures ready for six major exhibitions. She sent two strong oil paintings to the "Century of Canadian Art" exhibition at the Tate Gallery in London. They were "At the Lake," a 25" x 30" canvas lent by H.A. Southam, and the ubiquitous

"Plough," a slightly larger canvas, 30" x 40", the picture her friends never let her leave alone until it finally settled into a rather unusual, stylized painting.

Robert Ayre, art critic of *The Montreal Star* for many years, liked her way of working. He wrote: "There is never any fussiness of detail. If she puts a plough into a landscape or a wheelbarrow it looks like a workable implement as well as a substantial part of the design." He called her a "designer who imposes her own vision, her own sense of composition on what she sees but who loves the earth too well to become completely non-objective."

She exhibited at the Golden Gate Art Expo in San Francisco in 1939 as well as at shows in Montreal and Toronto. "St. Sauveur" went to the Canadian Group's show at the New York World's Fair. Well-modelled but somehow monotonous the picture has been justly called "derivative" of the Group of Seven. It is today owned by the National Gallery along with a canvas titled "After Rain," a livelier painting with a clear light falling across rain-washed fields.

Anne Savage attended few of the 1939 exhibitions. Jackson wrote her from New York where he had gone to supervise the hanging of the Canadian Group's show which occupied the Canadian Art Gallery of the Fair from August 1 to September 15:

Just going out for a last look at the show. We got it all up yesterday, hottest day of the year here. It looks good, cheerful and alive. I don't care a hoot what the Americans think.

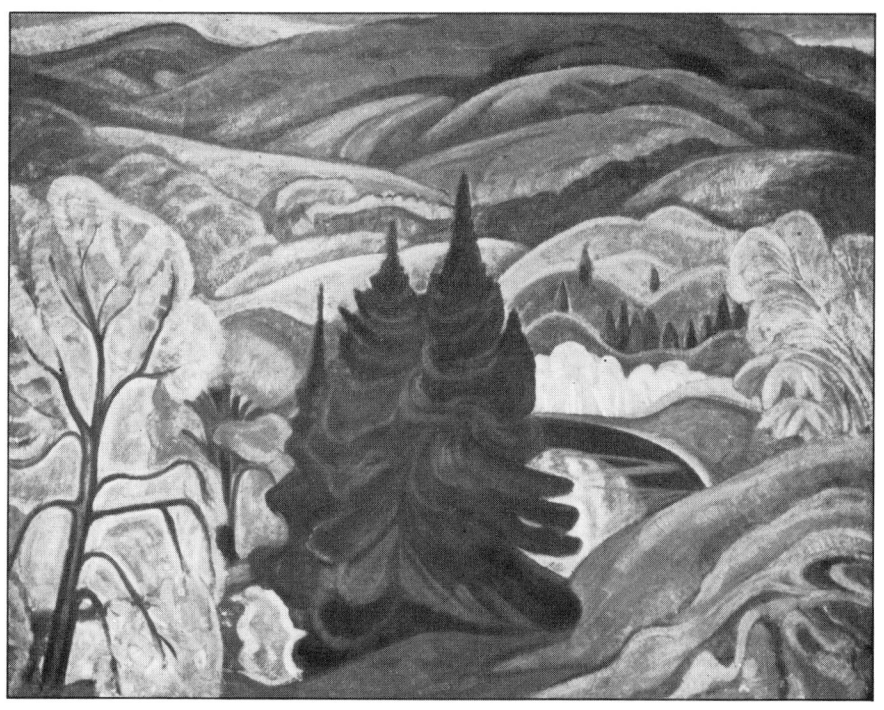

St. Sauveur

A second letter, written from Espanola, Ontario when he got back, included a sketch of the paintings, noting the picture "Lake Superior Village," by Charles Comfort, in the centre of the wall.

Jackson also sent a copy of *Saturday Night* (a tabloid in those days) which had a front page spread showing eight of the New York entries. However, the Canadian painters didn't attract anything close to the amount of attention they had received at the 1933 Atlantic City show. These were uncertain days in the US. *The New York Times* showed Spencer Tracy playing at the Roxy, and Hitler on page 13. Guy Lombardo and the Hot and Sweet Swing of his Royal Canadians got more attention than the art exhibit did. By the close of the Canadian exhibition the Canadian news that was making the American papers was the country's quick mobilization and the curious fact, which confused the Americans, that on September 12 the Canadian pavilion suddenly took down the Red Ensign and flew the Union Jack, not, as was supposed, in support of Britain, but because the Canadian flag had been ripped in the wind.

Anne's pleasure over the exhibitions was marred by the war clouds that loomed and broke over the world in the fall. Jackson, whose political colouring had been for some time what was called in those days "parlour pink," had often included in his letters brief comments on social conditions as he saw them. Now, as the Depression gave way to World War II, his viewpoint hardened. Tucked into his letters to Anne are provocative articles by the Canadian political analyst Judith Robinson and the American

Dorothy Thompson. A.Y. wrote from Grace Lake on August 28, 1931:

We got a newspaper, things seem to be in an awful mess in Europe. There is nothing worth fighting for, it will merely be to uphold the class privileges of old Chamberlain's set.

And just before this, indignantly:

There is one solution a lot of the ruling classes in England would consider, that is to make an alliance with Germany, giving her equal rights with the British all over the Empire.

Strange to hear Jackson speaking of the Empire, he who had been one of the strongest voices urging Canada to stand on her own twenty years earlier. He had been thinking in terms of art, but his statements had wider implications. It had been his nationalistic drive, in fact, that had caught the imagination of Anne Savage and many like her in the twenties. It would take the 1939-1945 war, however, to bring the senior of the Dominions to a sense of political maturity and independence.

As the situation in Europe worsened, Jackson wrote Anne almost every week, often in despair. She got this unusually flat note from L'Islet, *"en bas Québec"*, one of his best-loved haunts, on March 31, 1940: "It's a job making sketches, but I'm going to stay and squeeze them out, time is no particular object."

When the so-called "phony war" abruptly changed

with the German breakthrough into France, Jackson wrote on May 16, 1940:

What a week, with civilization and everything we hold dear tottering on the brink of a precipice . . . It's hard to paint, you can't keep your mind on it.

And on June 24:

The paint just dries on my palette, though I have three canvases under way.

As the Germans swept through France during that "black spring," he wrote calling on the artists to help:

There was more bad news crowded into yesterday than any day in the world's history. I believe the artists will be given a chance to stir things up, get their brains working. It's time something was said for democracy, or else we may look back on it in days to come as a kind of golden age.

In reply to some questions from her as to what might be done immediately he wrote:

I should think Arthur Lismer would know about occupational therapy, how about the Deichmanns [Kjeld and Erica Deichmann, potters from New Brunswick] running a pottery school. There should be fundamental crafts, weaving, carving, etc. Most of the soldiers were only taught nuisance crafts.

Anne Savage continued the fundamental craft of teaching children. At the Art Gallery they continued to crowd in to paint. Writing in *Saturday Night*, November 16, 1940, Robert Ayre said: "It is encouraging that the young men and women, in a period when the demands of the State grow in urgency, should be able to find time for art. For those still happily ignorant of war, Miss Anne Savage and Miss Ethel Seath are continuing their Saturday mornings."

Anne's "Saturday mornings" were less busy when Arthur Lismer came to Montreal in September 1942 to take over the classes and build up a Child Art Centre. It was a fulfillment of her earlier remarks to Jackson. It also meant a continuation of her own long association with Lismer. Jackson wrote her:

> *To the art life of Montreal it should mean that it will become the most active centre of the arts in Canada. . . . Keep him busy twenty hours a day and keep him surrounded by young people, send him to every school in Montreal and get him drawing funny pictures at parties.*

When Lismer arrived he asked Anne to continue teaching the older students. After a year of that, she wrote Jackson that she was happy to bow out.

Perhaps because the war depressed A.Y. she seldom mentioned it. On June 1942, however, she wrote:

> *How did you feel about Cologne? Could you bear it? What a death agony Europe is in. We'll be going over there next to see the latest in town planning and modern*

design and Quebec will be the only bit of mediaevalism left.

And later that year:

Did you hear Brockington [Leonard Brockington, Ottawa lawyer and political commentator]? He has just given a picture of Britain and when you hear of all the people working on dictated jobs it makes you think that the work of the artist as an interpreter and relaxer is going to be very badly needed. They don't realize it but art is the only thing that will bring them back to normal. So keep it up Alex and watch your horizons.

One of the more cheerful developments for Anne Savage in these dark days was the National Film Board movie of Jackson's life. He had earlier sent her drawings which Lismer had done of the projected film. As it progressed he sent her bulletins and did his best to keep his "girls" happy by wearing their gifts. He wrote her on November 17, 1940:

The socks arrived. They should be in the next instalment of the movie, the first part of which I hear is very good. But when do you find time to knit socks, my dear?

The following spring he wrote:

If the warm weather keeps up it will be funny putting on Sarah's [Robertson] scarf for the movie. It's too mild

Drawing by Arthur Lismer spoofing the Jackson film
(sent by AY to ADS early 1940's)

of a Canadian Painter

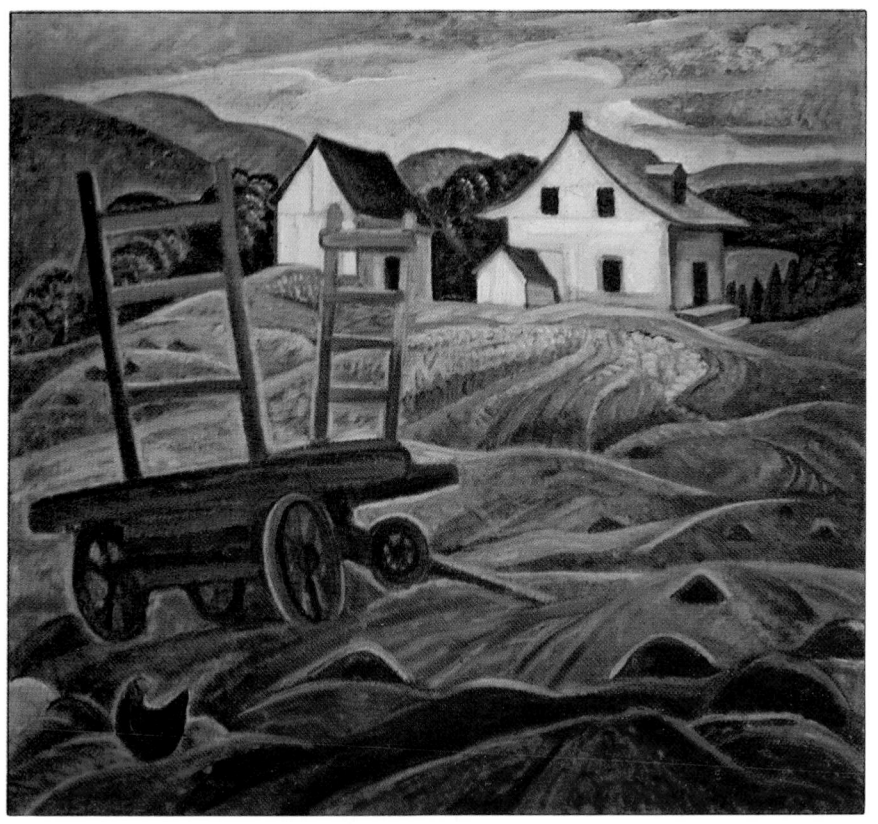

After Rain (1940's)

Anne Savage: Story

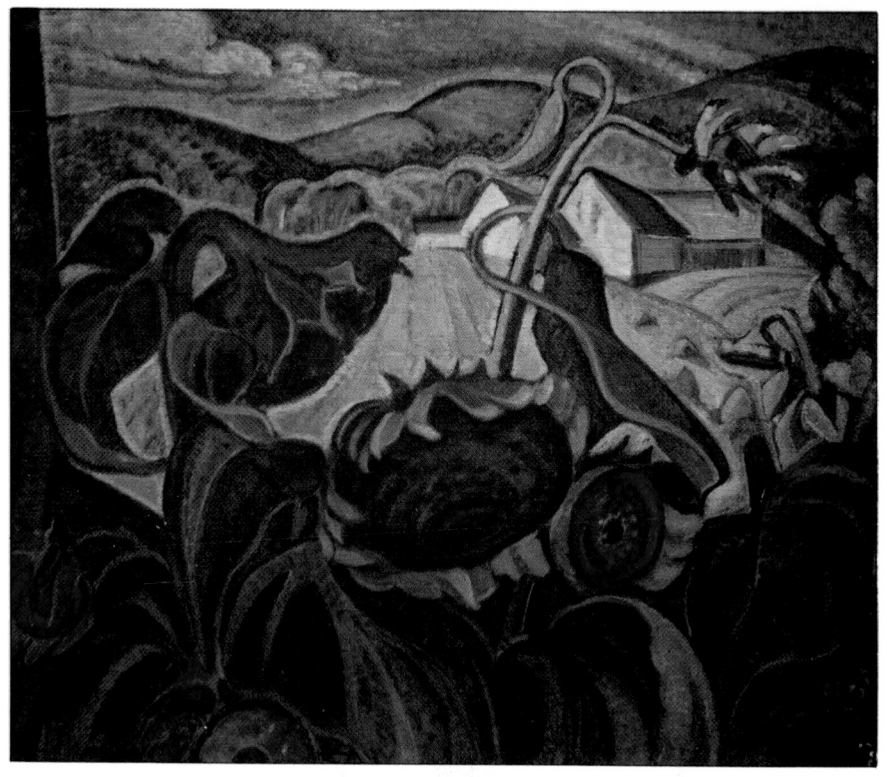

Untitled Sunflowers (1930's)

even to wear gloves. We will have to pretend it's a bitterly cold day.

When it was finished, Anne often abandoned the lantern slides and ran the Jackson film with her lectures. After a talk at the YMHA she wrote:

It [the film] came out better than I have ever seen it and they got a lot out of it. It is really fine. When is the Thomson one coming?

For that one Jackson was asked to go up to Thomson's stamping-ground in Algonquin Park and help with the background information, but he wrote her May 21, 1941, from Smoke Lake:

This country is all tame now. Thomson would have been fed up if he had lived. We used to talk of going further afield. . . . The film will be mostly of the country he painted in. They will not try to have anyone impersonate him.

Jackson's letters at this stage are beginning to take on a wistful note. He was almost sixty and was going back over old tracks. The Western light that had beckoned them both to break away from familiar paths and take a chance flickered low.

Anne Savage spent these summers in the Laurentians and during the early forties sent work to Canadian Group shows in Toronto and Montreal, as well as to the Canadian National Committee on Refugees and the Maple Leaf

Fund Exhibition in New York. The Maple Leaf Fund entry "La Petite Niche," is now in the McLaughlin collection in Oshawa. It is beautiful, pastel-toned, and has the fresh quality of her early pictures.

As the war went on her life became more pressing. The difficulty of trying to juggle home and school demands with some painting of her own almost tore her apart. By this time she had the worry of an ill mother. And like many others she took on extra commitments for the war. She invited an English woman and her two boys to Canada to get them out of London. They stayed at Highland Avenue for most of the war. At school she had the children design war posters and Jackson wrote:

I told Harry McCurry [director of the National Gallery] about what your youngsters have been doing with posters.... I suggested to the Art Gallery that we should have a war poster competition in connection with the British War Pictures.

Anne finished illustrating a little book, *Avançons*, for French classes in the junior schools.

I can remember Christmas at this period. We made the regular family pilgrimage from Toronto in a train usually full of soldiers. We had one kitbag full of presents and another packed with winter clothes, skates and sometimes skis, to use on Mount Royal. We piled into Highland Avenue along with the English evacuees. The house was small and its tiny rooms were arustle with tissue paper. Nightgowns and bedjackets were being finished. Pots of

jelly, grape and apple, were packed into baskets. There was holly from the west coast keeping cool in a box between the two front doors, a big tree squeezed into the corner by the piano, Christmas carols, and dozens of other family people dropping in.

It is now apparent that Christmas had always been a special time for Anne Savage and A.Y. It was the time of year when he tried to get back to Montreal and see his own relatives and also look up the painters. But there could have been little time for them to get together. Christmas was above all the season when Anne set her own life aside for other people's interests. Had she lived today, when a woman's life is more her own, Anne Savage's interests might not have been lost in a stack of Christmas decorations designed for everyone else's pleasure. And yet I can remember taking my turn "delivering presents" with her. We would set out in her little car with the snow falling and the lights on the trees along the Boulevard. Our destination was the Claxtons' "Pink House" on Cote St. Antoine. By the time we got back to Peel Street the snow might or might not have been cleared away.

Perhaps the key to her attitude can be found in a letter she wrote Jackson one year when he didn't get down to Montreal: "It was a lovely Christmas and it came off very well. That sounds like a 'show' but by the time everything has been attended to it just about is." She never could resist a good show.

In the summer of 1941 Anne Savage and Jackson both attended the Kingston Conference on the Arts. He wrote

her June 19, 1941, just before the conference opened:

> *You were right about the danger of making the show at*
> *Kingston a Canadian Group show. You arrange a show*
> *without thinking of anything but good canvases and then*
> *you find out it is almost a Canadian Group show. I left*
> *my name out but I expect André [Bieler, the Kingston*
> *painter] will borrow something from Ottawa. . . .*

In Kingston, they still think of the conference as a signific-
ant turning point for the arts in Canada. From its findings
came the decision to commission the Massey report and
study government help for the arts.

Pictures of the meetings show Anne as a thin, shadow-
eyed woman. She looks like Virginia Woolf. Her mother
died the following year, 1942.

If A.Y. had turned to her during the dark days of the
war, it seems to have been her turn now to look to him for
love and comfort. She wrote on February 14, 1943:

> *The snow is falling thick again this February night, so*
> *keep your fires cosy and shut your windows tight; so with*
> *best wishes for the week, goodnight my dear, goodnight.*

In the summer of the following year, on June 18, 1944, she
sent him a letter at Banff where he was teaching summer
school.

There's no way to paraphrase this letter although it's
tempting to do so. It is as fantastic in its stilted sentences as
Jackson was in the sentimental musings he wrote from his
tent. Canadians always hide their feelings, in life and in

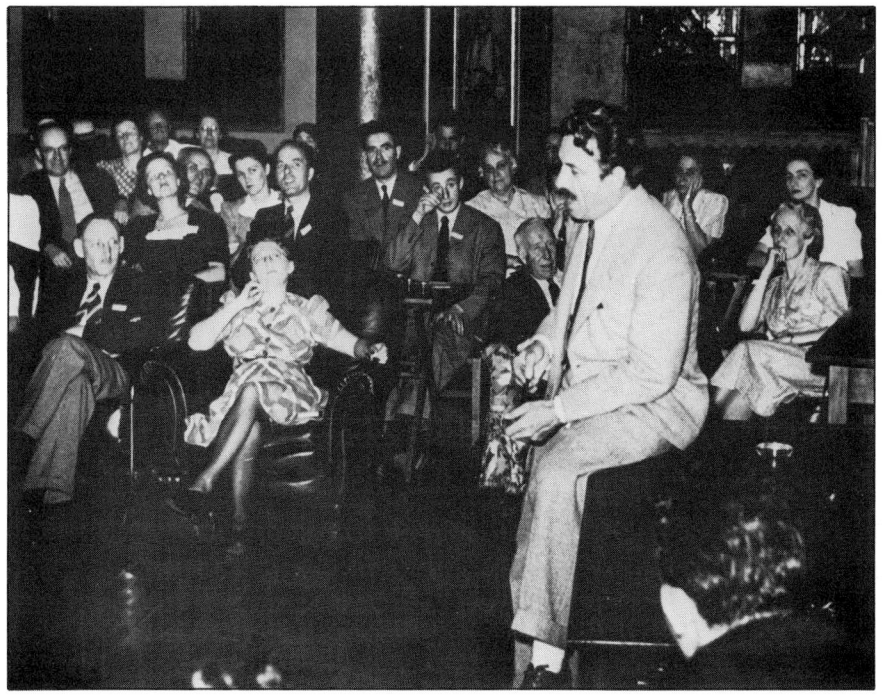

Kingston Conference of the Arts (1941)

books. These were two great Canadians and here is how one of them felt. Without practice, shy to death of this sort of offer, she waited too long to make it. Between two ordinary people, this would be a kind of Victorian romance; between two artists it was something else. Shyness is easy to see in these letters, but caring is also there.

4090 Highland Avenue
Montreal, Que.
Dear Alex,
How are you. It was good to see you on Tues.
I want you to read the enclosed just before you turn in tonight. I don't want it to upset (a or any) good day's work.
Cheerio
Pleasant dreams
Anne

June 18, 1944
Dear Alex,
It was like old times having you on Tues. night with your coat of tan and the lovely peep of Quebec. Those greys and greens were good. You are the finest painter in the land, Alex, and still are.
But it is you yourself that I'd like to talk to and somehow the last twice I've been perfectly helpless to express myself. But I am compelled to write this to you and you must forgive if I overstep the mark. But I can't just let it go on — and it seems very foolish to be tied by conventions on the last stages of the journey.
Alex, you've always meant a very great deal to me.

You've inspired me and helped me in every way, and I am very fond of you but I always was so afraid of imposing on you that my indifference has amounted to coldness and ingratitude.

But I know what a hard life an artist is forced to live — that incessant pushing of the problem to be solved and the lack of interest on the public's part makes it one continual scramble — and then the need for emotional stimulus and the effort to be true to the art within you. All that is a struggle. But Alex, I also know that friendship which has stood the test of years if properly adjusted could become a bulwark against all ills and create a haven or a shelter which could face any tempest. I know that the spiritual life is the only real one — that the little things of worldly estate don't amount to a row of peas. But it is hard to find that perfect relationship. Perhaps it only exists in heaven.

To seek one's own personal happiness is hopeless but to be able to help someone else would be well worthwhile. I have my work — you have yours and you would be as free as a bee and we could help one another and perhaps out of all this confusion and perplexity find our peace.

Don't try to answer this. It is just a whisper to your heart, when you are away out at Banff and have a quiet moment.

I shall be at Wonish a month from today — and remember Alex I'll understand. It is only what is best for you that will be best for me. And so may the Bon Dieu bless you and keep you safe — forever and ever.

Anne

There is no record of an answer to this letter.

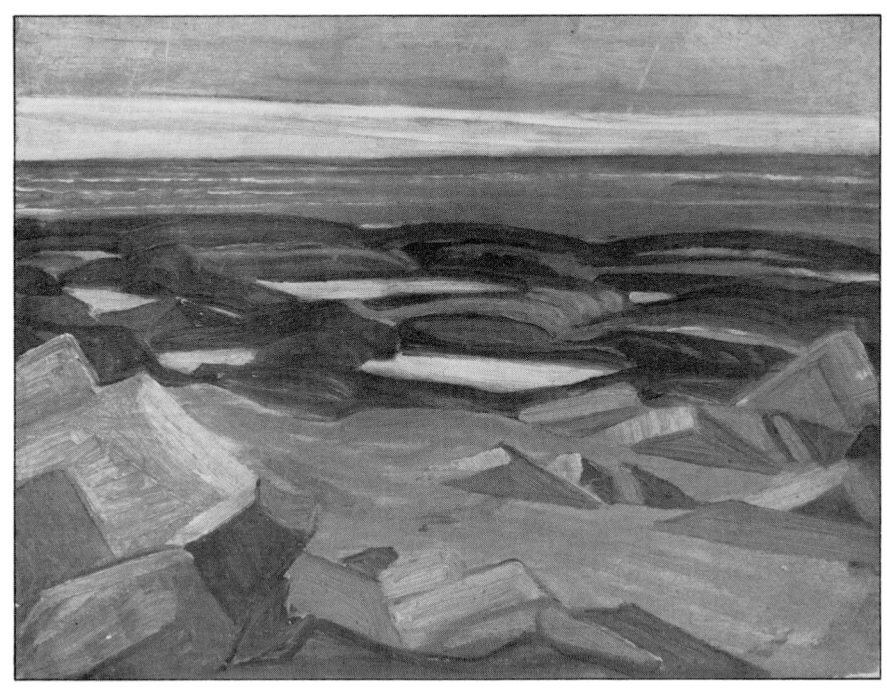

Sandy Bay, Métis (1950's)

II
Professional Woman

How foolish it is ever to try to express
one's feelings in words when paint is
the only medium.

ADS to A Y J, 26 April 1948

Anne Savage accepted the demands of her career. In 1948, after teaching for twenty-six years at Baron Byng, she was appointed Supervisor of Art for the Protestant Schools of Montreal. The position took her out of her own art room and put her on the road, visiting twenty-five schools.

The executive and administrative challenges of supervising did not give her the same lift as her own teaching. She wrote A.Y. on October 5, 1948:

My programme is just getting into play. It is giving me more variety. There are always losses and gains in any change. Never shall I experience the joy and excitement of real creative teaching as I did at Byng, when the staff was at its peak, when Dr. Astbury was principal and six other good friends were there. They have gone and the joy seems to be waning. So maybe it is better that I slip out and the good thing is that a lovely girl whom we trained is coming [Leah Sherman]. I still have three days at Byng and two on the road, but my mind is more on the other job because I think next year I'll have to take over.

Visiting 25 schools means a visit every 3 months and what can one do with that? Life doesn't lack for interest but my painting will have to just wait for a while. I'll have to depend on you for my spiritual refreshment.

Jackson continued to send encouragement but his letters were by this time almost perfunctory. Anne was on her own. He wrote on November 22, 1948:

You will have to be very tactful and very persuasive but quite firm ... you will be. You must be having an

interesting time, running into all kinds of people, helpful and enthusiastic and suspicious and apathetic. You can get them all working with you and you will.

Even as a supervisor, Alfred Pinsky says, she was able to show the art teachers how she worked and they caught her enthusiasm and could take it from there. For example, Anne used a tactic she called "Going for a Walk with your Chalk." She once said she worked it out to help children who couldn't get started on a drawing. They picked up a colored chalk or crayon and she would walk with them across the paper, telling them a story the whole time; "Up to the corner" she would say, "to post a letter and then back down to the grocery store and around the square and then back to the middle." They would end up delighted with their own "abstract." This was a kind of play-acting. The teacher in charge often caught the mood and the children could continue alone. The procedure was to become part of the school schedule. But one supervisor's play-acting may not be another's. After Anne Savage left, Pinsky says, the exercise became a static thing.

Grace Campbell succeeded Anne Savage as Supervisor of Art. She says she felt trepidation in replacing her because Anne was still talked about in school circles. The School Board relieved her doubts by saying: "We don't want another Anne Savage. Do it your own way."

For Anne the forties ended with a happy summer. Once again she went out west. She joined A.Y. at the Banff Summer School of Fine Arts, where he had been on staff for the past ten years. He wrote in anticipation on January 10, 1949: "Young [Joe] Plaskett is going to teach

at Banff, so with you and André [Bieler] and myself we will have a good little group working together"; and later, on February 15: "Expect you have received the Banff booklet. I hear John Piper is coming from England, good choice, they want me to go out two weeks ahead"; and again, on March 8:

Donald Cameron was in town. He informed me that you and I and my niece will all be in the same house. I did not even know Geneva [Jackson] was going. We should have a lot of fun. Bawden the English painter will probably be coming out too.

Anne became a good friend of Edward Bawden, who visited at Highland Avenue during succeeding summers and gave her two of his paintings. Letters from Bawden found among her papers invite her to visit him and his family in England.

Bawden shared some of her reservations about the Rockies. She told Calvin: "In the evening Bawden used to say 'I have to go now and paint some more of those damn conifers.' " For Anne Savage the western trees upset one of her tried-and-true teaching techniques, based directly on the Group of Seven and its stress of nature at the expense of the human figure. She explained:

Coming from Quebec, one of the first things I used to do was to start in drawing trees. The tree is like a human being, starting with the root and then the trunk, just like a figure, and then the muscles of the shoulder and the branches like limbs, then the twigs like your fingers and

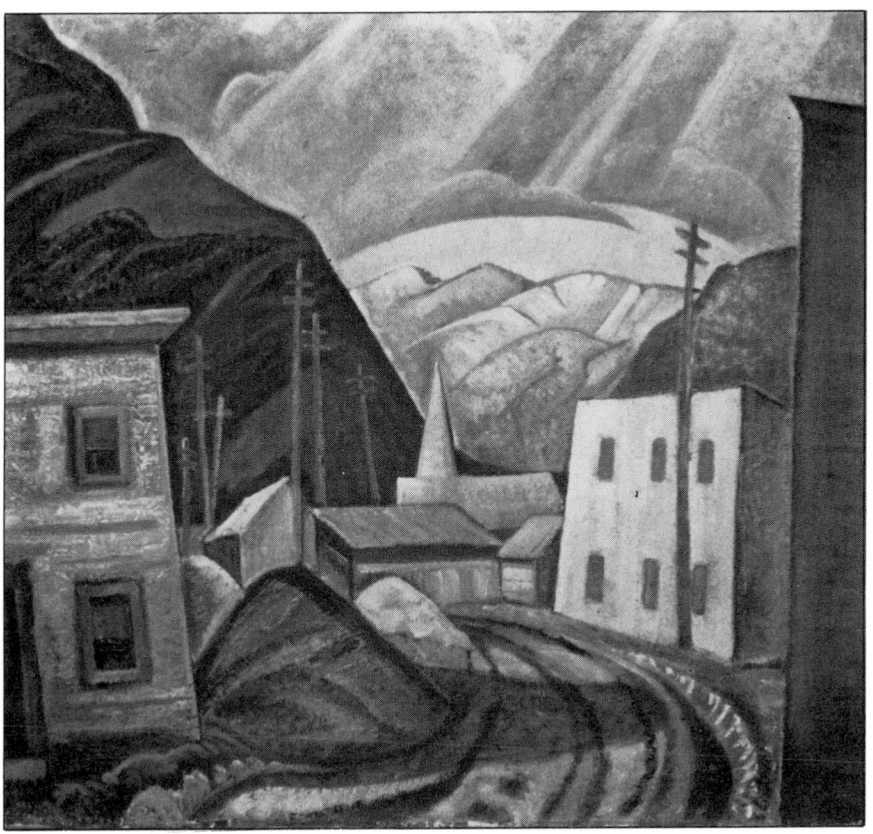

Northern Town, Banff (1939)

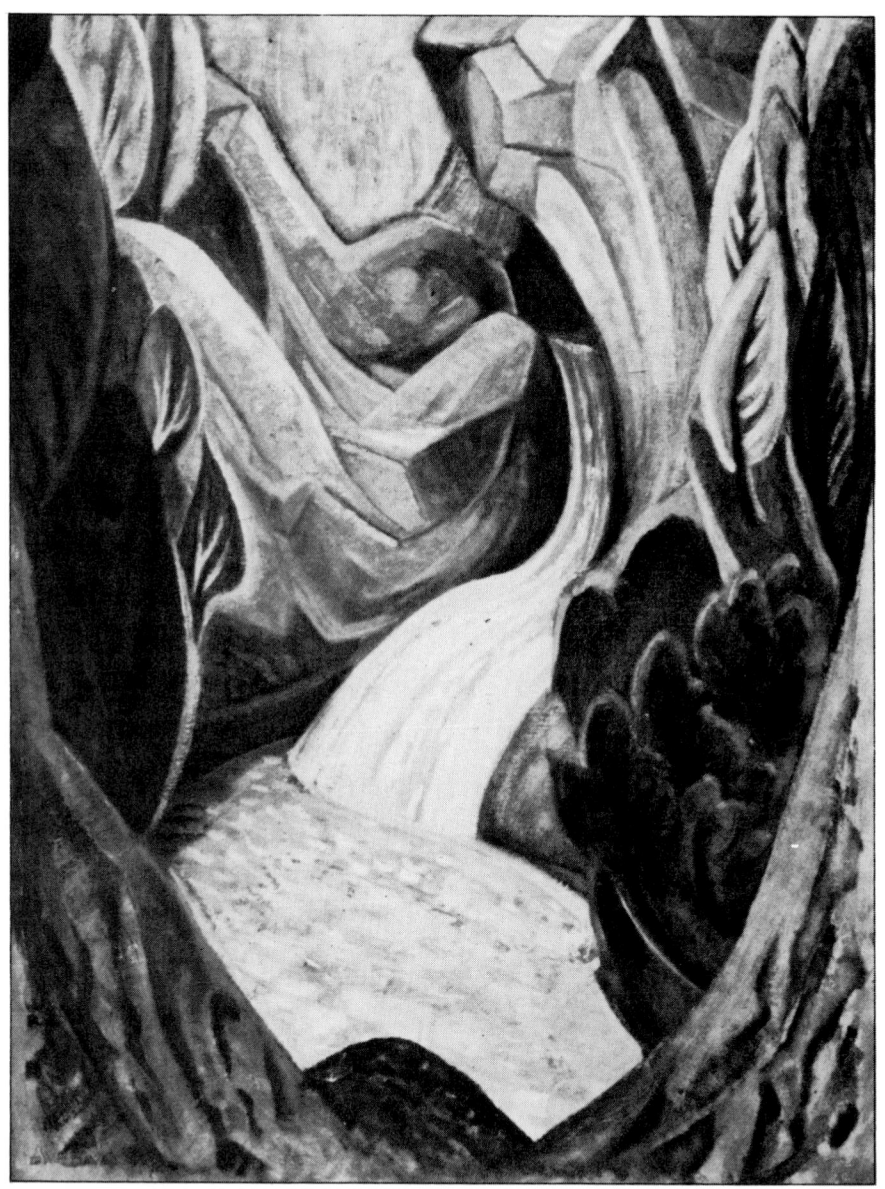

Sundance Canyon (Banff, 1950's)

leaves like finger nails. The whole thing went along beautifully and then suddenly I found myself facing an audience of adults and they didn't know anything about a tree. There are no maples or elms in the west. Nothing but conifers. For my own painting I found the west too vertical. The beauty of the Quebec landscape is the lead-in and the lovely feeling of the country moving back and the light and so on.

She told of one unnerving experience at Banff on a sketching trip. She described the procedure:

Everybody would 'locate' themselves. They would run up steep hills and sit on a high rock and the job of the teacher was to go plodding after them. This girl had got herself way up on a tree and I thought I could get to her. I started to slide on a pine needle path. We were on the end of a canyon and it just came down like this. . . . I saw a pine tree and thought well if I can just hit that I'll be alright. I did, and came down. That was called Sundance Canyon. I did a painting of Sundance Canyon and it went to the Group show and was sold.

The painting reflects verve and a sense of drama. It belongs to Dr. Lauder Brunton of Guysborough, Nova Scotia.

Donald Cameron, today a Senator in the centre block on Parliament Hill, remembers that summer and remembers Anne Savage from the hundreds of teachers he brought out west before he recently retired as head of the Banff School. He recalls her as a dignified person who got on well with

the students and had a good influence. And then he broke into a smile: "I remember her once out sketching at Moraine Lake. She loved that."

It's as good an example as any of the double image of Anne Savage as both career woman and painter. She spent her life balancing the two roles. In fact, she never made a choice between them. Her nephew, Galt MacDermot, was to say with some of the hardness of another age, a different artistic temperament, or perhaps just simply as a man: "I think Aunt Annie made a mistake. She had a great perception – in painting – and she let family things, her mind, and education and what people thought she should do, get in the way of following it totally."

This was about the time that those of us who had known Anne Savage as children were starting college. I used to go up to Highland Avenue from the smug confines of McGill residence, sometimes arriving too early for dinner, and would meet the whole Canadian Group of Painters, Montreal branch, at the close of an afternoon meeting. I can remember the high, arresting voice of Dr. Lismer and his tall figure looming in the little hall; stocky, grey-suited Miss Seath; nervous, charming Miss Morris; golden-headed Gordon Webber; and a dark mass of others, all chatting happily. On the big old dining-room table were the remains of tea, brandysnap cookies and chocolate cake.

Anne Savage was to be president of this branch four times. When she did take on professional duties she kept careful notes. These have survived in a little black book called "Minute Book" which was found in her desk at Highland Avenue. A close study shows how the Montreal-

ers tried to paddle their own canoe with Toronto steering.

The book lists the active members at that time (this record starts with 1942). In addition to the original Beaver Hall Hill painters and Arthur Lismer, who had now joined the Montreal scene, there were Louis Muhlstock, Fritz Brandtner, Marian Scott, Goodridge Roberts, Jacques de Tonnancour and the architect Gordon Webber. Bellefleur was to be a member for some years.

The pages contain the names of many contributing members, those invited to send paintings to Group shows. Some of these were asked to join, others on the list were not. Some were asked to join but declined.

For example, a meeting was held on November 2, 1945, at the Art Association. Fritz Brandtner chaired it. A report from the jury for the 1945 Canadian Group show that was to open in Toronto on November 21 was read. The artists included: Emile Borduas, Stanley Cosgrove, Alfred Pellan, Jori Smith, Philip Surrey and William Armstrong, among others. "There is perplexity," the Minutes note, "on the question of voting these into membership." It was suggested that the Montreal members go on record as saying that those who had exhibited consistently should either be dropped from the invited list or proposed for full membership in the Group. The next entry is January 12, 1946. The matter is not discussed, but other questions were raised. Louis Muhlstock moved that invited contributors' work should not be included in the travelling shows of the Group due to space limitations. Gordon Webber objected, pointing out that even if invited contributors' work were shown while some full members'

The Canadian Group of Painters – Montreal branch (1946)
L. to R.: Gordon Webster, Ghitta Caiserman, Jimmy Jones, Gentile Tondino,
Fritz Brandtner, Ethel Seath, Kay Morris, Leon Bellefleur, Arthur Lismer
(Anne Savage not present)
Anne Savage's friends: Florence Wyle, Lilias Newton, Frances Loring

works were not, the exhibition would still represent what the Canadian Group felt to be the most important canvases of that year.

Like all minute books this one seldom gives the answers to many of the questions raised, but the period was full of interest. How far was non-objective painting encouraged and invited, for instance? While the art community of Montreal in those days, French and English, was small enough for painters to know and contact each other, one wonders by what criteria members were judged.

Looking back it is clear that the significant happening at this time was in no way connected with this established group. It was a vibrant upsurge in Quebec painting led by Alfred Pellan. The movement had started gradually and had always run counter to the Group of Seven concepts. In spite of Jackson's early cry to the French Canadians to "paint Canada" when he opened the Beaver Hall Hill show in 1921, most of the French painters took another route and were to paint as strong individuals, taking their inspiration from some inner vision rather than surrounding landscapes.

It was not only that they studied in Paris. Many of the English painters did too, including John Lyman, who had always held that painting was a concern of the inner consciouness and had resisted the drive to paint landscape in what he considered the rough manner of the Group of Seven. French Canadian painters like Marc-Aurèle Fortin, Adrien Hébert, and later Jean-Paul Lemieux concentrated on their own style of quiet, private painting. In the forties Quebec was swept by the vigorous, personal abstract painting of the loner Alfred Pellan, and after him came Borduas and Riopelle.

It was almost a question of timing. The earlier painters had looked at the rough country around them and felt compelled to define it. Now that the Canadian backdrop had fallen into place, the house could be furnished with more intimacy. Graham McInnes names four painters as prominent in the Quebec renaissance: Paul-Emile Borduas, Goodridge Roberts, Stanley Cosgrove and Jacques de Tonnancour.

These painters must have felt restless at some of the Group's meetings. Anne Savage found herself divided. In a letter to A.Y. of February 2, 1948, she wrote: "You are right about the modern trend. It lacks direction and so blocks and circles fall in to fill the space." In spite of her loyalty to Jackson, however, she continued: "But I must say I should love to have time to experiment with different approaches."

She sounds pleased with the criticism she received from Fritz Brandtner, a Montrealer who painted with bold slashing strokes and acid colours in the semi-abstract German Expressionist style. He visited Lake Wonish in August, 1948 and she wrote A.Y.:

Fritz dropped in for his yearly visit, looking like an Alpine climber, very well. He tore everything I ever painted to bits, but he is very entertaining and very helpful in criticism.

The Montreal Group continued to meet until 1967 when the Canadian Group disbanded. Jackson often gave Anne Savage credit for keeping the Montrealers together but she would deny it. She was sometimes involved, however, in

trying to explain the Montreal position. On Oct. 29, 1954, she wrote A.Y.:

There is some dissension as to the organizing of the voting. They want to elect their own representatives and really it would be better. You see there are some people here who have never been in office and it stands to reason that the local people know their members.

Jackson wrote her after a meeting in Toronto which broke up in bickering. He was, however, fighting a losing battle trying to keep the group together. He believed that in the future, when Canada's population had doubled, the country would need more art groups, but in fact conditions developed differently. Instead, more galleries, better arrangements for grants to individuals and a wider marketplace, along with a growing awareness of art in the general Canadian public allowed artists to survive as individuals; they no longer had to band together in order to show their work. Theatre people continued to work in groups, but painters no longer needed to.

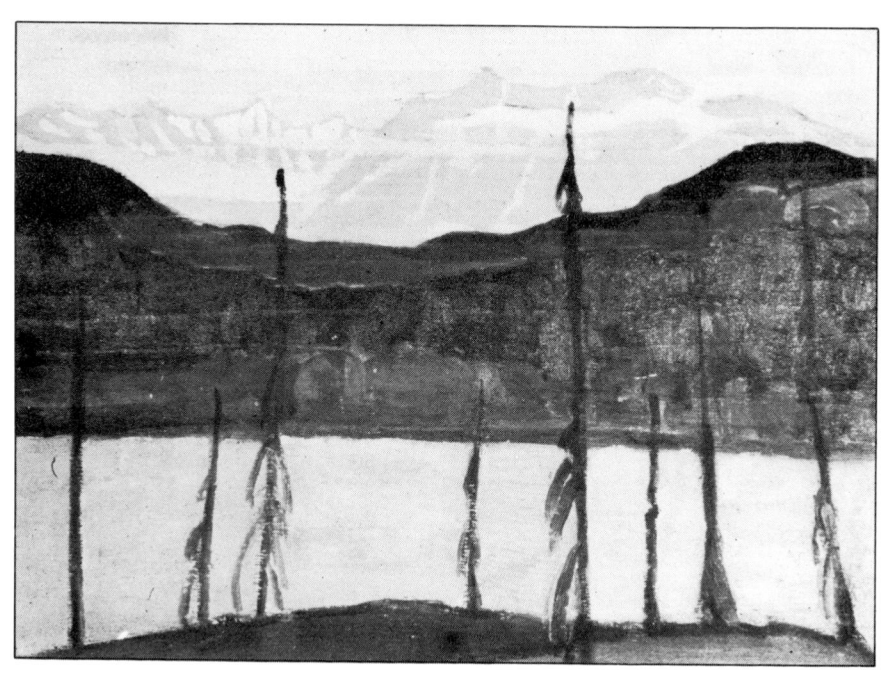

Untitled oil sketch (Skeena, BC, 1928)

12
Back
to Paint

The only thing to do is to paint to
please yourself and have a lot of fun.
I hope that is what you are doing.

AYJ to ADS, 18 April 1959

In 1952 Anne Savage retired from her supervisor's job. After thirty years of beginning work at 8 a.m. every day, she rejoiced in being able to call her time her own.

It took some time for her to reorganize her life as a painter. She had become available for other jobs and accepted two offers: teaching a weekly class for the new Art Education students at McGill, which she did for five years, and organizing a series of twenty lectures for an evening adult education class, held at the Thomas More Institute.

She wrote A.Y. about the first job on October 29, 1954:

Have taken on the McGill Education Art Course. The teachers from McGill met this morning at Byng and it is a real treat to work with them, so gay, so fresh and a wonderful satisfaction to see how the art in the schools has developed.

I have one evening group at the Catholic school, the Thomas More Institute, giving a twenty-lecture course. I only organize it. Bob Hubbard [today Chief Curator at the National Gallery] came down last week and gave a very good talk on Canadian art. He is a sensitive, intuitive person, how wonderful if he became head of the NG. Is there any chance of it?

She was asked to sit on art juries. Jackson had something to say about one of her jobs, writing February 7, 1950:

Glad to hear you are on the jury of the new Canadian nickel. Frances and Florence are not having anything to

*do with it. They think it should be limited to sculptors and
I am afraid that I don't agree. It's a designer's job. Once a
good design is found they could turn it over to someone
who specializes in that work.*

The Hungarian-born designer, Stephen Trenka, who came
to Canada in 1929 and lived in Thornhill, Ontario, was
eventually chosen to design the new five-cent piece.

On another occasion she was asked to help judge a
competition run by the Brooks Bond tea company, to send
the best art student of the year to Europe. Harold Beament,
an artist living in Montreal, remembers serving on this
committee with her. The other members of the jury were
Charles Comfort and Alfred Pinsky.

Anne Savage had sent work to a Six-Women Show in
Toronto in 1950 and Jackson wrote: "Anne Laidlaw liked
your 'Sundance Canyon'." In 1956 she was asked to give
her own one-woman show at the YWCA in Montreal. She
wrote A.Y.: "I have had a busy time with a little show at the
YW: 20 entries, 12 canvases, sketches, etc." Many of these
"canvases" were done on gesso board, a medium which
allowed her to paint and scrape and repaint the surface
again. It was the first time she had put this new technique
on display. She told A.Y.:

*In the new building of the 'Y' the entrance hall is very
well lit and a lot of people pass in and out who might
never go to the Gallery. Anyway I made 10 sales — a
windfall — and so I am putting water pipes into the studio
at the lake."*

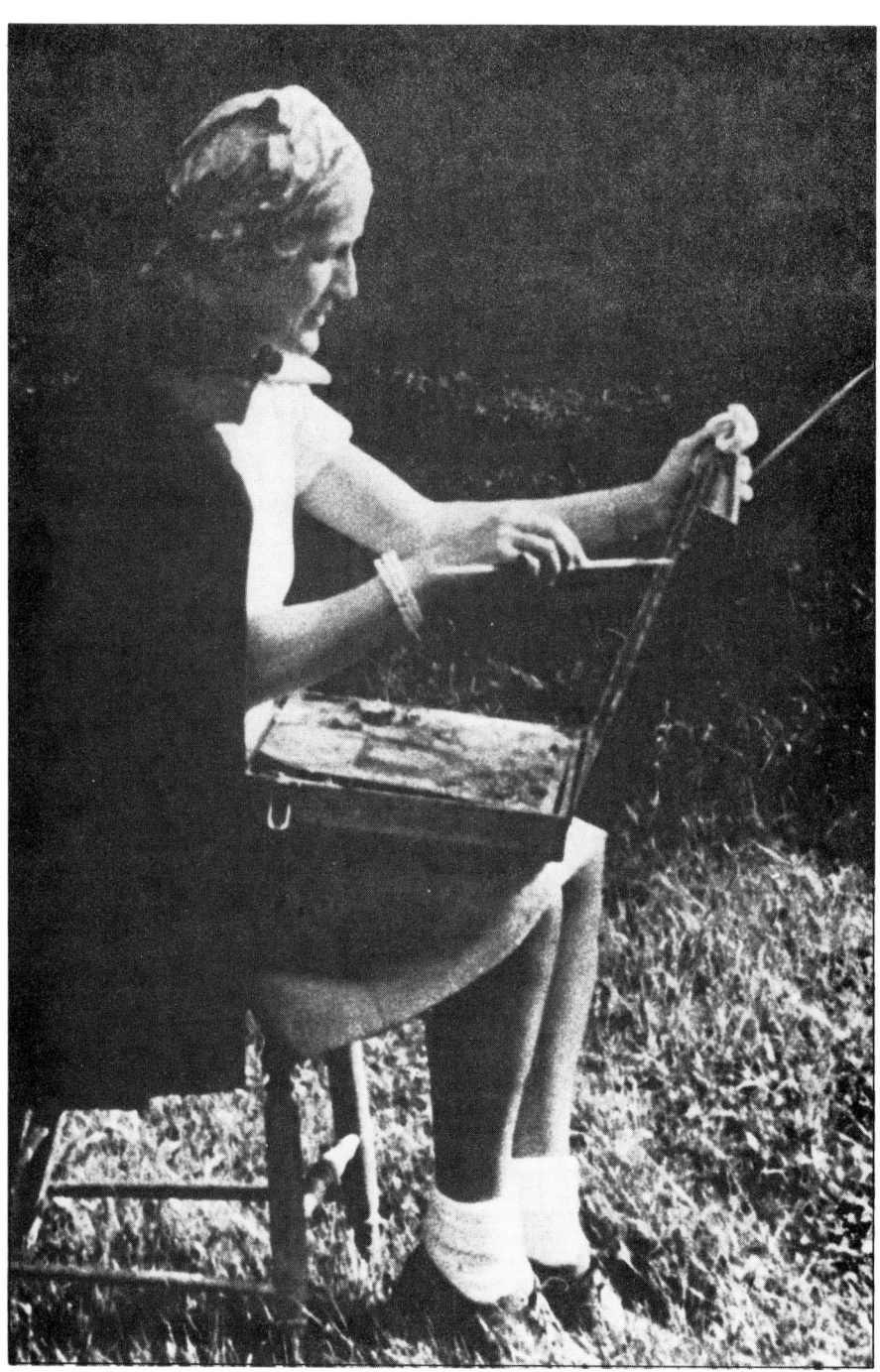

Anne Savage sketching

Up to this time all three houses on the little lake up north had been geared to a primitive form of existence. In the early days this lifestyle was considered part of "getting away from town." Water was carried from the spring for drinking and pumped from the lake for washing. There were wood stoves, candles and coal-oil lamps which were gradually supplemented by electricity and oil heaters. The old wood stoves still sat in the kitchens. No one who had felt their comfort could bear to throw them out.

Anne managed to get away for longer periods these days. In time, she became better known in the village of Sixteen Island Lake whose houses and church she used to paint. She would sit straight and dignified on her sketching stool, paintbox on her lap, while children gathered to watch. The people of the village liked her and gave her the kind of respect they reserved for favoured teaching sisters of the church. Because she came off-season as well as in the summer, the villagers gave her first attention whenever she wanted a cupboard built or a pipe fixed. She in turn had more time to think about their lives than the summer families did, and would keep in touch during the winter months which stretched very long and cold in those hills before television came to open their world. She was very much loved by the family living closest to Lake Wonish, Léo Tassé, his wife and their seven sons. They still refer to her as "Miss Annie."

By this time she was entertaining great-nieces and nephews at her studio. They ran over all summer long to visit her just as their parents had done. She showed them how to "draw" or model in plasticene. They made puppets and put on their own shows. She often played the

piano for songs. She was to find, however, that the cold of a bright September or April day crept into the uninsulated summer house and she eventually spent more time in the sunny upstairs room at Highland Avenue which became her studio after the last niece and nephew had moved out. From there she did a number of paintings of the houses opposite and the hillside behind, often in a soft winter light with shadows across the snow. This was where Arthur Calvin interviewed her; she showed him her sketches and made him tea.

A.Y. had come to stay at Wonish once or twice over the years. He was 78 when he paid his last visit. He wrote Anne on April 18, 1960:

We drove up your road at Sixteen Island. A woman told us there was no one there. Wonderful sketching weather, sunny, warm and cool at night and plenty of snow around Morin Heights but only the odd drift left at Arundel.

She sent a picture that she finished at Wonish, "Autumn Bouquet," to the Montreal Museum of Fine Arts (as the Art Association was now called) in 1956. It is a lovely composition, mixing the new scraped technique with her firm sense of design. The colours are fresh: blue, yellow, pink, white. It attracted the attention of Charles Laughton who was in town for a reading and was taken through the Museum to see some examples of Canadian painting. He rang her at home. The incident gave her great pleasure. She had often told us how much she loved his readings. In

1956 she sent an earlier canvas, "Lower St. Lawrence," to the CNE in Toronto.

Jackson's letters at this time lack the enthusiasm he earlier had. He wrote her "The factory is working and the canvases rolling out like Ford cars." He could not possibly keep up with the demand for his work and so was only faintly bothered by the non-objective waves all around him. "We had quite a time on the jury," he had written from a Canadian Group show in Toronto, 1950, "a good deal of compromise. We ran into a lot of abstractions and no one on the jury knew whether they were good or bad. We have no standards to go by." Two artists he acknowledges are Harold Town and York Wilson.

In 1948 the Studio Building that had been his home for thirty years was sold. He settled for a while, rather uneasily, at Manotick, just south of Ottawa. He was by this time a celebrity in the world of art, and lionized by ladies' tea parties and hostesses eager to have him as guest of honour at black-tie openings. He reports this to Anne rather wearily, as on November 7, 1958: "Settling down to rural bliss in Manotick is not so simple as it seems. They shove me into the limelight." He was happier setting out for Great Slave Lake, where he finished a series of sketches in his late sixties, or exploring new sketching ground such as the hills of Ripon, just north of Ottawa in the lower Gatineau hills. Of that landscape he wrote: "We will investigate and see if it can be reduced to rhythm."

To rhythm, but not to blocks and circles. On May 13, 1956, he wrote her from Manotick: "I would not let my canvas go on the Travelling Canadian Group show. It is

better that it should be all modern." He would never accept the changes in Canada's "statement." He wrote on September 14, 1958:

Art in Canada is in a funny muddle, a great deal of public support going to non-objective stuff, a lot of it went to Brussels. The other countries sent the same kind of thing. International art – we don't seem to have received any bouquets.

On September 4 of the following year, he was even more upset:

There are now so many non-objective artists that not half of them can get their work in exhibitions and it has become necessary to bring in Americans to decide between the wheat and the chaff. And of course they have not the slightest interest in anything that is Canadian in feeling.

Anne Savage did not try to argue. But she did try new techniques, perhaps influenced by her students. Pinsky says: "That kind of rhythm of the hills, in her pictures, represents the collective outlook. It broke ground at a time when everyone was admiring the academics. But Anne talked about more modern things. Her mind was always concerned with art developments. She never pretended her style was the only or best way. She wanted to try new things."

Although she would live another thirteen years, her strength was almost spent. "After thirty years of teaching,"

says Jacques de Tonnancour, "I don't see how she got back to painting at all."

She might have done more painting during the fifty's, made some of the trips both her sisters and A.Y. urged her to make and seen more of her artist friends, if she had been alone. But she had taken on yet another commitment and it was to colour her next ten years.

At the beginning of Anne's retirement Miss English was able to help with household tasks. As time went on she became ill and bed-ridden. Anne Savage would hear nothing about her leaving. Anne looked after Miss English just as she felt she had been cared for all these years. Her behaviour with the older woman was extraordinary and bordered on the saintly. Never short-tempered, Anne humoured and cared for her as if she were a child. It was in fact, a reversal of the nurse-child relationship that had initially brought Margaret English into the household. It meant driving to the country in an ambulance for a couple of summers. It meant that Anne Savage was almost completely tied to an invalid.

Her sisters regretted the situation but were unable to help. They knew quite well that Anne was an affectionate woman with a very kind heart who could not see someone suffer without trying to help. They also knew that once Anne had decided that it was her duty to help, she was very stubborn and would not be stood down.

These years had a marked effect on her. Her enthusiams, which had sometimes bordered on impatience in the early years, changed into a rare ability to accept things as they were. Without the pressures of a career, Anne's ever-present gentleness became even more appar-

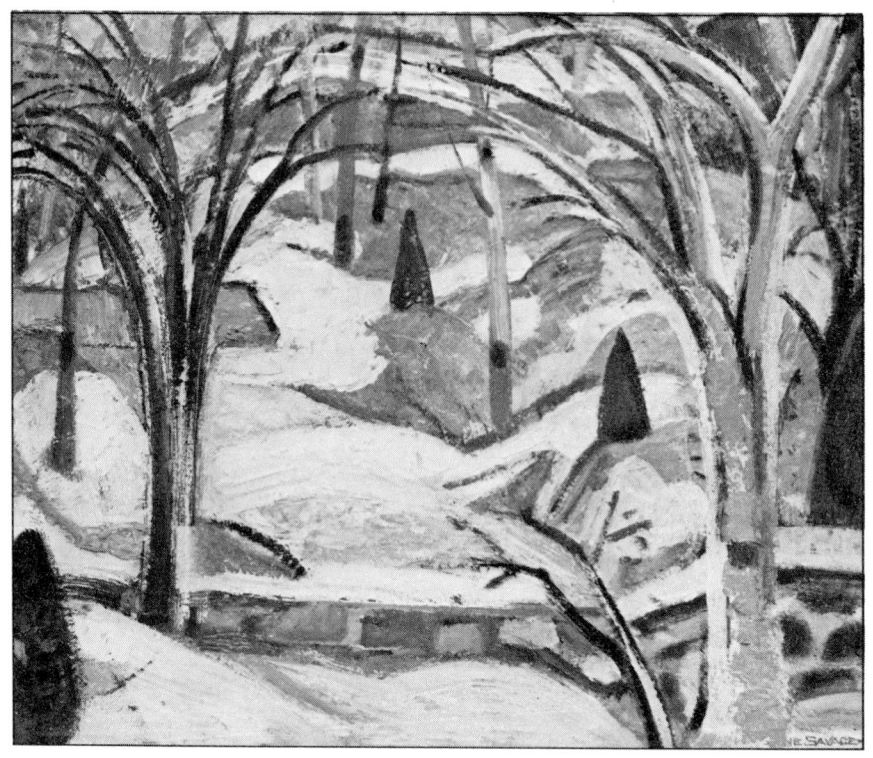

Winter Afternoon

ent. She had always been a joyful person, during these years she changed into a serene one. Norah McCullough compares her face, now like fine parchment, to a drawing by Leonardo da Vinci.

Miss English died in 1965. For the first time Anne Savage faced the prospect of her own mortality. She lived in pain by this time, first from arthritis, which moved through her body, and later from cancer.

She devoted her last years to painting. Edwin Holgate was sitting in his Montreal apartment surrounded by his own early paintings when he spoke of his old association with the Beaver Hall Hill painter. "Toward the latter part of her life you could see a spiritual change. She pitched the colour high, used a lot of pinks and yellows, became more abstract." He added: "She always had a very broad human outlook. She was like André Bieler, neither of them self-seekers. They just kept painting."

In 1974, I talked with Lilias Newton, another close friend of Anne's. The last portrait Newton painted stood up on the easel in her apartment on Sherbrooke Street. She was always more sophisticated than Anne Savage, though perhaps they shared the same kind of courage and pride. She spoke of Anne's last paintings: "I liked her later colours. I think she got better and better. When she was perfectly free her painting went ahead like anything. She used acrylic. I liked when she painted and scraped and painted again on top."

The best painting Anne ever did, in Lilias Newton's opinion, went to the Canadian Group's show at the Beaverbrook Art Gallery in 1960. Called "Summer's Done," it was reproduced in Fredericton's *The Daily*

Gleaner on February 16, to announce the show's opening. It is a picture of big ragged sunflowers hanging over a fence. It gives the impression of space, and has strong rhythm. Anne loved painting sunflowers and her sister Helen used to plant them in the cottage garden especially for her. Curiously, although she frequently painted sunflowers, she rarely used their name in a title. For Anne Savage, Van Gogh had a unique place in art. He had painted the definitive "Sunflowers," and she didn't want to trespass on his territory. Her big painting "Autumn Fantasy," done in the thirties, has a powerful motif of country sunflowers in the foreground, but there is no mention of the flowers in the title.

Her work was shown in the sixties. A.Y. wrote from Toronto on November 16, 1960: "Went to the opening of the Canadian Group show. Your canvas looked very well. It sold the opening night."

She wrote him about the Montreal Spring Show in 1961, quite realistic about her own position in the field of "modern art": "My own painting looks like a fish out of water. As Lilias says: 'We are both practising a lost art — portraiture and landscape'." The Montreal Museum later bought her picture "Laurentian Landscape." In 1963 she held a show at the Artlenders Gallery in Montreal with the Kingston painter André Bieler.

And yet her last paintings are done in a modern medium. Tobie Steinhouse, a Baron Byng pupil who had grown close to her as a friend and fellow painter, saw her often during the last years. She liked the new technique Anne was developing and thought she brought it to perfection in a study of white cyclamen. It is an ethereal

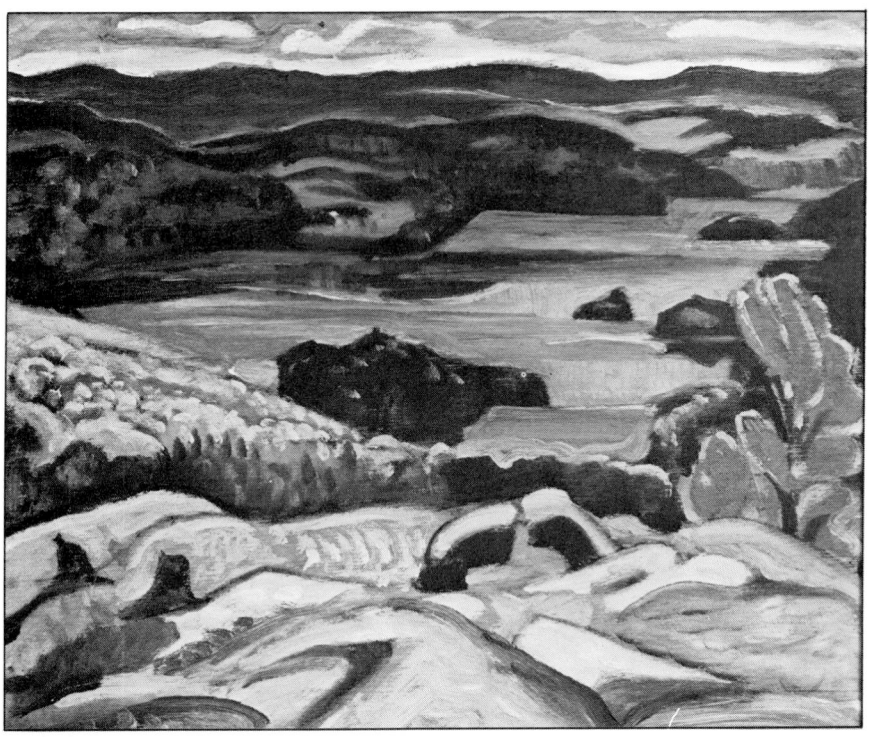

Sixteen Island Lake (1930's)

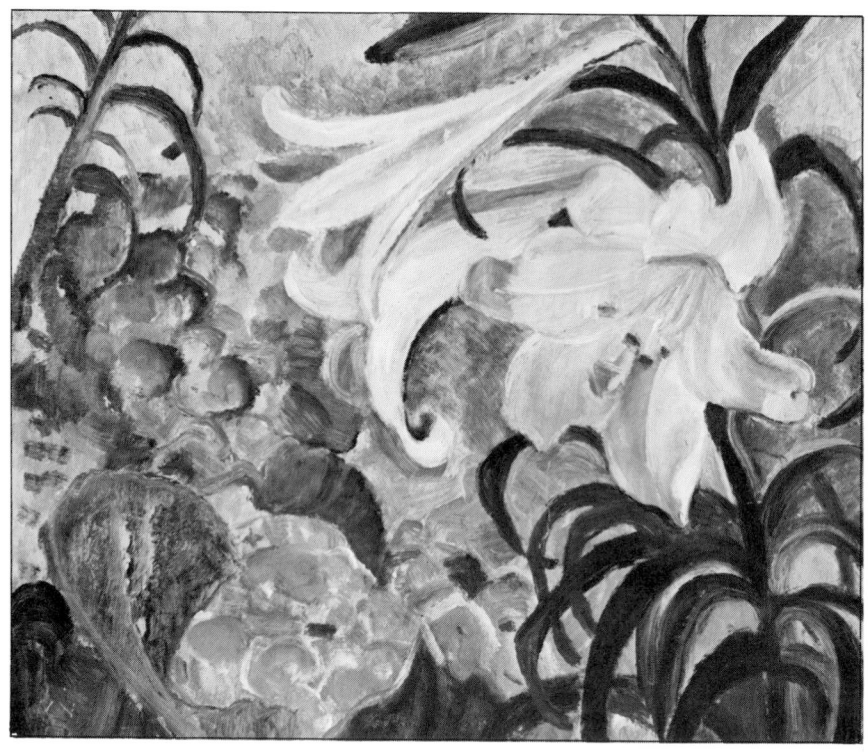

Easter Lilies (1950's)

painting, the medium almost used to create transparency. She did not do many like this. Some of the larger ones were never finished.

Anne Savage and A.Y. Jackson kept writing each other, sending books and even Valentines until the end of their lives. They hardly ever made any direct mention of their feelings to each other. These they expressed through art or other artists. They did discuss the way of an artist's life, and the mysterious quality of beauty; why one artist should find it in both his art and his human relationships, why another should fail to do so.

Anne very early revealed the identity of her personal idol when she wrote A.Y. in 1944:

One more week of the Dutch exhibition. There might be a slogan 'Paint like Vincent [Van Gogh] or not at all'. And that would mean not at all. And then there would be nothing but – the hemlock – It struck me so forcibly that he never perpetrated anything that was ugly or sad. It was all radiant and today the morose and cynical are the vogue.

Van Gogh always meant a lot in her life. She used to tell us about him and sometimes read part of the letters from his brother Theo. It was Van Gogh whom Sir Herbert Read used as an example of an artist who got no help with drawing as a child. He burned in anguish "waiting for someone to share the fire," as Read said in his 1957 lectures at the University of British Columbia. This may have been a part of Anne Savage's own teaching inspiration, helping children make contact with the world of art. Read used

other examples, Henry Moore and the painter Raphael, to show how artistic talent, when encouraged in youth as it was in these men, can result in serenity.

But A.Y. Jackson, who had once written of Lawren Harris: "He is like some traveller with his eyes on some far off goal, who no longer sees what is around him. I don't feel that way about life," wondered about an artist's life.

Writing Anne on January 31, 1958, he says:

I have been reading about Piet Mondrian, what a fine person he was. Quite a resemblance to his compatriot Van Gogh in his early work but while Van Gogh's passions tear him to pieces, Mondrian rises to a realm of austerity where nothing concerns him but his ideas. . . . What is hard to understand is that Van Gogh found no one but his brother to appreciate what he was doing. Mondrian, who was doing work almost incomprehensible, found helpful friends wherever he went.

A.Y. wrote more about this painter two years later:

What a strange person he was, a kind of saint. Mondrian was eighteen when Van Gogh shot himself. They were both neglected but Van Gogh much more than Mondrian. The last twenty years of his life Mondrian spent in painting abstracts of horizontal and vertical lines seeking a perfection that means nothing at all to most people, while Van Gogh's work draws crowds of people . . . artists are a queer lot.

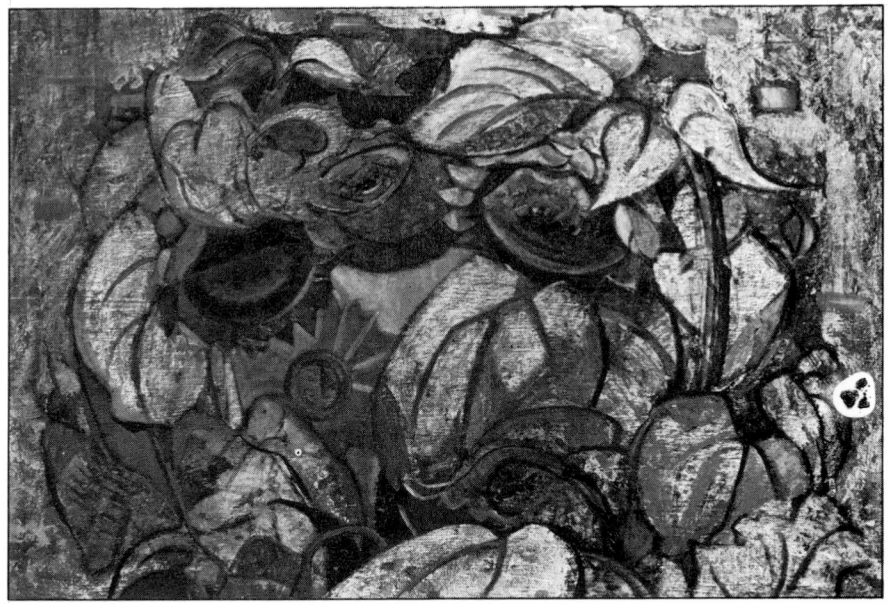

Untitled Sunflowers (1968)

A.Y. was soon to go to live at Kleinburg. The last letters Anne kept were written March 26, 1963 and March 8, 1964. Jackson was by then over eighty. He told her: "All the best to you, keep up the good work. It makes me feel very sad to think of the old days in Montreal, as ever, Alex" and:

Keep on painting according to your own convictions. I find an awful lot of people who still like some trace of nature in their drawings. All the best to you, sincerely, Alex.

He kept a letter from her dated January 23, 1967.

It has been an exceptionally dark winter, very hard to paint. But the days are getting lighter and there is a feeling of spring even in the midst of snow.

On June 28, 1968, she sent him a card in Ottawa, c/o his niece Naomi Jackson Groves.

So good to hear from you and to know that you are feeling better. Wonderful if you can move from the hospital. It will be a nice change.
The Sir George Williams University are giving me a Retrospective. So I am now trying to round up the lost sheep. Keep on improving, all good wishes, cheerio, Anne.

A.Y. Jackson did not get to her Retrospective.

The university Fine Arts Department collected some sixty paintings, all oils, spanning a period from 1928

("Paradise Lost," "Skeena River, BC") to 1968 (Summer's Done" and "Lake Wonish in July"). The show ran from April 4 to 30. Many of the hundreds of people who came were surprised by the extent and variety of Anne Savage's work. They had not realized that she had been painting for so long or how summer work can add up over a period. Many thought of her as a teacher only.

Anne Savage went to opening night. She could hardly walk. She stood with a cane and gave her last performance. No one who was there will ever forget her radiant happiness. Her own students had organized this show. She thanked them. She said nothing could make her happier than that they should be the ones to show her work.

Three years later she died. In the hospital her sisters opened letters to her from A.Y. but the writing was illegible. They were probably urging her to get better and, in the phrase they had used down through the years, "grab the odd sketch." That was the spirit that bound them together, the enduring foundation of the dream of the Western Islands. She followed it to the end.

Exhibitions

AAM Art Association of Montreal
AGT Art Gallery of Toronto
CGP Canadian Group of Painters
CNE Canadian National Exhibition
NGC National Gallery of Canada (Ottawa)
RCA Royal Canadian Academy of Arts

1918 Montreal Art Association. Spring Show.

1925 British Empire Exhibition at Wembley.

1927 Musee du Jeu de Paume, Paris.

1927 NGC.Canadian Annual Show. "Laurentian Hills" –
 oil; "The Hills in Spring."

1928 RCA-AAM."Kitwanga Hills, BC"; "Rocher de Boule,
 Kispayan, BC."

1927-28 NGC. Exhibition of Canadian West Coast Art.
 (Toronto Gallery, 1928). "Temlahan, Upper
 Skeena River"; Group of Sketches, Upper Skeena
 River.

1928 AAM. Exhibition of Contemporary Canadian
 Paintings. "The Canyon of Usk"; "The Owl
 Totem"; "Rocher de Boule, Kispayan, BC."

1929 RCA-AGT. "Hills on the Skeena."

1929 AAM. Spring Show. "John."

1929 CNE. "The Laurentians, April."

1929 RCA-AAM. "Shacks at Percé."

1929 Second Exhibition of work by Quebec Artists.
 Eatons. Montreal. "Sketch: Brown Lake";
 "Laurentians."

1930 NGC. Canadian Annual Show. "Owl Totem";
 "Hills on the Skeena River."

1930 Corcoran. Washington. Exhibition of Paintings by Contemporary Canadian Artists, with American Federation of Artists. "Laurentian Village."

1930 Third Exhibition of Works by Quebec Artists. Eatons. "Sketch: Murray Bay"; "Ste. Anne des Monts."

1931 Baltimore Pan-Am Exhibition of Contemporary Paintings. "Shacks at Gaspé."

1931 AAM. Spring Exhibition. "July in the Laurentians."

1931 CNE. "July in the Laurentians."

1931 RCA-AAM. "Lake Wonish."

1931 Exhibition of Group of Seven. "The Plough."

1932 NGC. Canadian Annual. "July in the Laurentians."

1932 Montreal Artists. W. Scott's Gallery. "Red House"; "Laurentian Landscape."

1933 NGC. Canadian Annual Show. "The Plough."

1933 AAM. Spring Show. "Pines, Métis."

1933 CGP. Atlantic City. "The Plough."

1933 CGP-AGT. "A Pool, Georgian Bay"; "Twisted Pines, Georgian Bay"; "Le Buanderie, Métis."

1933 GCP. Exhibition of Canadian Clubs. "The Plough."

1934 CGP-AAM. "A Pool, Georgian Bay"; "Twisted Pines, GB"; "Le Buanderie."

1934 CGP. McMaster. "The Plough."

1934 AAM. Spring Exhibition. "The Plough."

1934 AGT. Massey College. "The Plough."

1935 AAM. Spring Show. "Little Balsam"; "The Still Pond, Georgian Bay."

1936 CGP. "The Wood"; "St. Sauveur"; "La Petite Niche"; "Green Shores."

1936 CGP-NGC. Travelling Show. "La Petite Niche"; "Green Shores."

1936 AAM. Spring Show. "St. Sauveur"; "The Wood."

1936 Dominions Reject List. "Green Shores."

1937 Empire Exhibition. Johannesburg. "St. Sauveur"; "The Wood."

1936 NGC. S. Dominions. "St. Sauveur"; "The Wood."

1937 Coronation Exhibition British Empire Overseas Jury List. "The Wheelbarrow"; "Autumn."

1937 British Empire Overseas. London. "Autumn"; "The Wheelbarrow."

1937 AAM. Spring Exhibition. "Laurentian Lake"; "The Poppy."

1938 Walker Art Gallery. 63rd Autumn Exhibition. Liverpool. "The Wheelbarrow"; "Autumn."

1937 CGP-AGT. "July at the Lake."

1938 CGP-NGC. "July at the Lake" (lent by H.S. Southam).

1938 Auction. Spanish Orphanage. Montreal.

1938 AAM. Spring Show. "La Petite Niche."

1938 London. Tate. Century Canadian Art. "The Plough" (lent by Massey); "At the Lake" (Southam).

1938 Committee, sale. "Aid Spanish Democracy."

1939 San Francisco. Golden Gate Art Exposition. "Spring Morning."

1939 AAM. Spring Show. "Autumn."

1939 AAM. Summer Exhibition. Contemporary Montreal Artists. "The Wood."

1939 CGP. New York World's Fair. "St. Sauveur."

1939 CNE. "Autumn."

1939 CGP-AGT. "The Wheelbarrow"; "A Northern Town" (Power Corp); "Cap a l'Aigle"; "A Laurentian Hayfield."

1940 AGT. Four Artist Exhibition. Print Room. "The Wheelbarrow"; "A Northern Town"; "Cap à

l'Aigle"; "Laurentian Hayfield"; "Autumn Morning"; "Owl Totem"; "La Buanderie"; "The Wood"; "Autumn"; "La Petite Niche"; "Laurentians"; "April"; "Little Balsam"; Four paintings untitled.

1940 AAM. Spring Show. "April in the Laurentians."

1940 NGC. Ottawa. Canadian National Committee on Refugees. "Corn, Quebec" (W.M. Southam); "Laurentian Hayfield" (Mrs. Plaunt); "September Evening"; "Eastern Townships" (Mrs. K.W. Taylor, Ottawa).

1941 AAM. Spring Show: "Spring, Seize Iles"; "After Rain"; "Cap à l'Aigle."

1942 CGP-AGT. "Spring, Seize Iles"; "After Rain."

1942 CGP-NGC. Travelling Exhibition. "After Rain."

1942 NY. Grand Central Gallery. Maple Leaf Fund. "La Petite Niche."

1947 Cdn. Women Artists. NY Riverside Museum. "The Wood."

1950 Six-Women Show. Toronto. "Sundance Canyon", among others.

1956 YWCA. 20 pictures on display.

1956 Mtl. Museum of Fine Arts.

1959 CNE. Toronto. "Lower St. Lawrence."

1960 CGP. Fredericton. "Sunflowers."

1961 Montreal Museum. Spring Show.

1963 Artlenders Show. Montreal, with André Bieler.

1968 Retrospective. Sir George Williams. 60 paintings.

1975 NGC. Painting in the Thirties. "Dark Pool, Georgian Bay."

1977 Art Gallery of Ontario. The Laurentians; Painters in a Landscape. "July, Wonish – 1960"; Sketches – "Lake Wonish, Easter"; "Lake Wonish, Thanksgiving."

Chronology

July 27, 1896	Annie Douglas Savage born
1911	Lake Wonish purchased by J.G. Savage
1916	Donaldson killed in war
1914–1918	Studied at "The Gallery"
1921	Beaver Hall Hill group formed
1922	Began teaching at Commercial and Technical High School
1922–1948	Taught at Baron Byng High School
1933	Canadian Group of Painters formed
1937	Began Saturday morning art classes for children at Montreal Museum of Fine Arts
Jan.–Feb. 1939	CBC talk – Development of Art in Canada
1941 (Summer)	Kingston Conference on the Arts
1942	Arthur Lismer came to Montreal and started the Children's Art Centre
1942	Helen Savage, Anne's mother, died
1948–1952	Supervisor of Art, Protestant Schoolboard
1954–1959	Taught Art Education at McGill
1950s	Lectures for evening adult education classes, Thomas More Institute
1965	Margaret English, family nurse, died
1968	Taped interview with Arthur Calvin
March 25, 1971	Anne's death
April 5, 1974	A.Y.'s death

A.Y. Jackson (1948)

Date Due

Hensall			
SEP 2 6			
FEB 0 8			
FEB 13			
JUN 1			
APR 1 2			
APR 1 4			
JUN 1			
JUN 8			
OCT 4	7 1986		
APR	3 1986		
MAY 3	1986		
DEC 1 0 1988			
OCT 1 7 1989			